Thomas Lowinsky

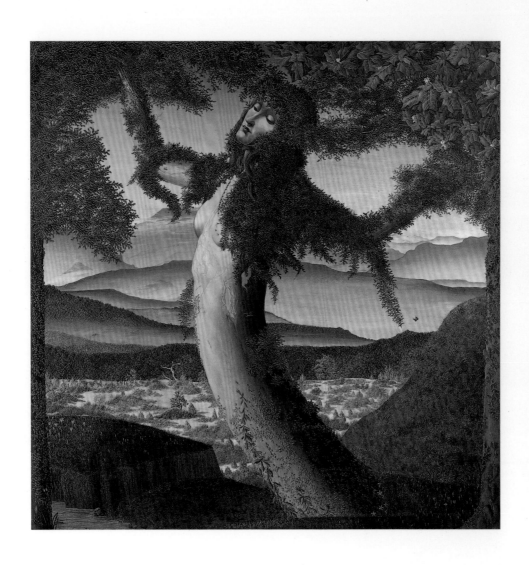

THOMAS LOWINSKY

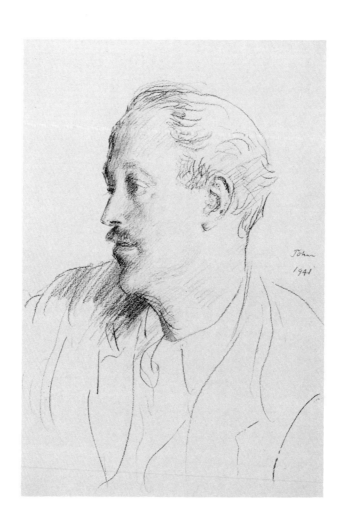

MONICA BOHM-DUCHEN

Thomas Lowinsky

TATE GALLERY

cover
Daphne 1921 (spring)
(cat.no.7)

frontispiece
Augustus John
Portrait of Thomas Lowinsky 1941
(cat.no.68)

ISBN 1 85437 040 5
Published by order of the Trustees 1990
on the occasion of the exhibition at the
Tate Gallery: 28 February – 16 April 1990
and then toured by the South Bank Centre to
The Mead Gallery Arts Centre, Coventry: 23 April – 2 June 1990
Graves Art Gallery, Sheffield: 9 June – 22 July 1990

Photo Credit: James Austin
Designed by Caroline Johnston
Published by Tate Gallery Publications, Millbank, London SW1P 4RG

Printed on Parilux matt 150gsm by The Hillingdon Press, Uxbridge
Typeset in Spectrum by Keyspools Limited, Warrington

Contents

Foreword

Thomas Lowinsky was relatively unknown as an artist during his life-time and indeed his work has not been seen much since his death in 1947. There have been only three major exhibitions of his work, the last at the Graves Art Gallery in Sheffield in 1981. If his name is known at all it is probably as a book illustrator, connoisseur and collector of British 18th and 19th century drawings, rather than as a painter.

This exhibition draws together examples of every aspect of Lowinsky's oeuvre but the most exciting aspect will, perhaps, be the paintings, about which Lowinsky himself was very secretive. His portrait paintings and highly imaginative compositions are intriguing and distinctive but refuse to fall within any particular historical or aesthetic category. It is hoped that this exhibition will be an opportunity to rediscover his work. We are very much indebted to the artist's family for supporting this exhibition so warmly and with such enthusiasm and would also like to thank Monica Bohm-Duchen, free-lance art historian, who has selected the exhibition and written the catalogue. This will be the first major publication on this artist.

We are happy to be collaborating with the South Bank Centre which is taking this exhibition on tour to the Mead Gallery, Arts Centre in Coventry and to the Graves Art Gallery in Sheffield after the Tate showing. We are delighted that Lowinsky's work will be seen by a wider public and our thanks are extended to all the lenders who have agreed to part with their works for such a long period.

Nicholas Serota *Director*

Acknowledgments

This exhibition would not have been possible without the willing co-operation of the artist's children, Justin Lowinsky, Katherine Thirkell and Clare Stanley-Clarke and grandchildren, Thomas, Robert and Serena Thirkell, Georgiana Keane, Rebecca Bedale and Jessica McVicar — to whom thanks must be extended first and foremost. Justin Lowinsky and Katherine Thirkell have been particularly unstinting of their time and memories. I am only sorry that the artist's sister Xenia Field's failing health has made it difficult for her to participate fully in the genesis of this exhibition.

Amcotts Wilson, another relation, has kindly lent a painting to the show. Special thanks must go to Anthony Hobson, Lilian Browse, Sir John Rothenstein and above all, Sir Brinsley Ford, for allowing me to benefit from their personal contact with Lowinsky. David Buckman, Ruari McLean and Ian Rogerson have been most forthcoming in suggesting fruitful lines of enquiry during the course of my research. Max Rutherston, Joseph Darracott, Paul Delaney, John Dreyfus, Robert Simon and Denys Sutton have also been helpful here.

Chronology

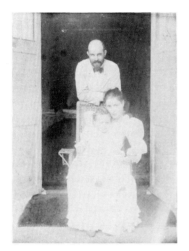

Thomas Lowinsky with his parents,
1893

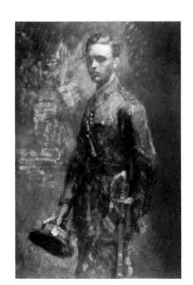

Ambrose McEvoy **Portrait of
Thomas Lowinsky** *c.*1917/18
oil on canvas 53¼ × 36 (135.3 × 91.5)
Justin Lowinsky

1892

2 March: Thomas Esmond Lowinsky born in India, eldest son of Thomas
Herman Lowinsky of Tittenhurst, Sunninghill, Berks. Family returned to
England while Thomas Esmond still a small child

1906–9

Attended Eton College

1911

Read English at Trinity College, Oxford

1912–14

Attended Slade School of Art, London

1914

August: on outbreak of World War One, enlisted in Inns of Court Officers'
Training Corps, obtaining commission in the Queen's Own Royal West Kent
Regiment (Second Lieutenant, Fifth Battalion)

1917

Transferred to Special Reserve of Scots Guards. Made full Lieutenant. Saw
active service in France, and was with Army of Occupation in Cologne

1919

April: demobilized

1919

25 April: married Ruth Hirsch and moved to 41 Kensington Square,
London W8

1920

Birth of first daughter, Katherine

1923

Birth of first son Martin

1924

Became founder member of Double Crown Club

1925

Birth of second daughter Clare

1926

February: first one-man exhibition (held jointly with Albert Rutherston), Leicester Galleries, Leicester Square, London

1926

Became member of New English Art Club

1929

Birth of second son Justin

1939

On outbreak of Second World War, family moved to Garsington Manor, Oxfordshire

1945

Family moved to The Rectory, Aldbourne, Wilts.

1947

24 April: died of cancer in London, age 55

1949

12 January–12 February: memorial exhibition held at Wildenstein and Co., New Bond Street, London

1981

One-man exhibition at Graves Art Gallery, Sheffield

Thomas Lowinsky drawing

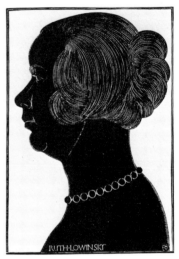

Eric Gill **Portrait of Ruth Lowinsky** 1924, wood engraving
9 × 6⅛ (22.9 × 15.6) *current location unknown*

Thomas Esmond Lowinsky (1892-1947)

fig.1 Greetings card for artist's father, Xmas 1912, showing family home, Sunninghill

Lowinsky's family origins, for an artist who to all outward appearances was the perfect English gentleman, were distinctly exotic. His paternal grandfather, Thomas, was an ardent fighter for Hungarian independence who fought alongside Lajos Kossuth in the Revolution of 1848-9 and was forced to flee, first to the United States and then to Ireland, where he married a Catholic girl and proceeded to change his surname from the perhaps overly Jewish-sounding Loewe (a derivative of Levy) to Lowinsky. The artist's father, Thomas Herman Lowinsky, who conspicuously failed to understand or sympathize with his son's ambitions, was a wealthy banker and keen amateur gardener who has to his credit the introduction of several new rhododendron hybrids. His mother was a Mosenthal, of German-Jewish banking stock, and very much under her husband's thumb. Growing up first in colonial India, where his father was acting as financial consultant to the Sultan of Hyderabad, and then at Tittenhurst, a large and luxurious house in Sunninghill, Berkshire (fig.1), Thomas Esmond's childhood was hardly lacking in material comforts.[1]

The father's ambitions for the son being firmly conventional, a reserved, introverted and artistically inclined boy was sent off to Eton College at the age of fourteen (having previously attended Mr Hawtrey's School at Westgate). Here his severe dyslexia combined with his failure to shine at sports (in marked and humiliating contrast to his younger brother, Rupert Esmond, the apple of his father's eye, with whom he shared a room) caused him to be labelled at best a dunce, at worst an idiot, and ensured that he remained an outsider. The artist's sister recalls that the one subject he did shine at was 'romantic history' and mythology. Only John (or 'Bunny') Hare, his housemaster and the tutor with overall responsibility for supervising his schoolwork, seems to have taken any real interest in Lowinsky, or to have in any way encouraged his artistic leanings. Nevertheless, it appears that his lifelong passion for collecting started while at school.

Eton led 'naturally' to Oxford. On 13 October 1911, Lowinsky was admitted as a commoner to Trinity College, where for a year he ostensibly read English, but in fact struggled to keep up. He seems, however, to have found the atmosphere at Oxford a stimulating one. Philip Guedalla, later to win fame as a historian, became a good friend, and it was while he was at Oxford that he first encountered the extraordinary Sitwell family. Having failed his first year examinations, he was discreetly removed by his father, and prevented from returning. Evidence of his artistic activities as a student comes in the form of a programme designed by him (fig.2) for an Oxford University Dramatic Society production of *Julius Caesar*, in which he also played 'another poet'. A love of the theatre was to remain with him throughout his life.

In the autumn of 1912, despite paternal misgivings, Lowinsky entered the Slade School of Art in London, where he was to meet his future wife, a fellow

fig.2 Programme design for *Julius Caesar*, 1911

student named Ruth Hirsch — of whom, more later. Bearing in mind the emphasis on life drawing and fluent draughtsmanship that then prevailed at the Slade (chiefly due to the influence of Henry Tonks), combined with the fact that drawing never came easily to Lowinsky (as he himself acknowledged), it is perhaps not surprising that he failed to shine.[2] He fared somewhat better under the tutelage of that other major figure at the Slade, Wilson Steer, who was to remain a family friend, immortalizing Ruth in a fine portrait of 1924 (fig.3).[3] His method of teaching, which Lowinsky described as one 'of gentle understatement', in marked contrast to that of Tonks, 'which combined vitality, eloquence, sarcasm and facile demonstration',[4] and the priority he accorded to colour and to painting over drawing would almost certainly have made Steer more congenial a teacher than Tonks. Lowinsky later recalled a comment addressed to him by Steer in 1913: '"Nasty colour", he explained, "never becomes nice colour. A picture has to be nice colour from beginning to end"'.[5] This was clearly a piece of advice that Lowinsky took to heart.

As is well known, the Slade in the years immediately preceding the outbreak of the First World War was a hotbed of radical new talent. David Bomberg, William Roberts, Edward Wadsworth and C.R.W. Nevinson, soon to become leading members of the Vorticist avant-garde, were all Slade students around this time. It is salutary, however, to remember that other major talents — notably Paul Nash[6] — remained relatively unaffected by a revolutionary spirit, and established the style for which they were to become well known only somewhat later. Significantly perhaps, many of Lowinsky's artist friends and associates in later life (Augustus John, Ambrose McEvoy, Albert Rutherston and Ethel Walker, among others) came not so much from the ranks of his exact contemporaries at the Slade, but from a slightly older generation of Slade students.

Certainly, if we are to judge from the few works remaining from that period (fig.4 and cat.nos.1–4), Lowinsky took a firmly traditionalist stance, producing compositions mainly of an allegorical or symbolic nature, executed in a relatively naturalistic if slightly heavy-handed manner. Little of the technical finesse or colouristic subtlety so conspicuous in his mature oeuvre is yet in evidence; although there is already an indication of his penchant for choosing somewhat unusual subject-matter and treating it in an unorthodox and rather enigmatic way. Although indebted in part to Charles Ricketts and the late Pre-Raphaelite tradition he represented (see p.15), his work of this period has distinct affinities with what David Fraser Jenkins[7] has called 'Slade School Symbolism' as embodied in the work of such artists as Augustus John, William Orpen and Stanley Spencer. He seems also to have produced a number of greetings cards in these years, at least one of which shows a clear debt to Aubrey Beardsley, whose work he greatly admired, both then and later.

War, however, intervened. Lowinsky enlisted at once, joining the Inns of Court Officers' Training Corps and then obtaining a commission in the Fifth Battalion of the Queen's Own Royal West Kent Regiment. To begin with, it

Artists Revel, 1914 (Thomas Lowinsky, back row, fifth from left)

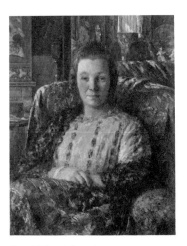

fig.3 Philip Wilson Steer
Mrs Thomas Lowinsky 1924
oil on canvas $27\frac{3}{4} \times 22\frac{3}{4}$ (70.5 × 57.8)
Clare Stanley-Clarke née Lowinsky

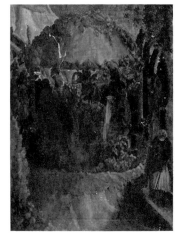

fig.4 **The Seven Ages of Man**
(study for a fresco) 1913, oil on canvas
48 × 36 –121.9 × 91.5) *T.G.L. Thirkell Esq.*

seems, he had both time and inclination to continue with his painting (see cat.nos.3 and 4). In the autumn of 1917 he was transferred to the Special Reserve of the Scots Guards, saw active service in France and was with the Army of Occupation in Cologne, before finally being demobilized in April 1919. Our main source of information about this traumatic period in Lowinsky's life comes in the form of his correspondence with the much older artist Charles Ricketts.[8] Lowinsky's initial experience of warfare seems to have been exhilaratingly – and disconcertingly – romanticized. On 23 August 1917, still safely in Kent, he wrote to Ricketts of a 'large German Air raid ... a sight I would not have missed for worlds', and went on to describe how '... there hovering above the town, like silver sequins in the sky, were ten Hun Gothas, and all around them little blobs of black, which were bursting shells ... we suddenly saw one burst into flame and come sailing down to earth like some exquisite fire-work. So beautiful was it that it was impossible to picture three men being burnt alive'.

By 30 October, however, he had changed his tune: 'I cannot tell you what the line is like – I will quote you a few lines from a letter found on a German which I think very expressive – "The line means endless strain and unspeakable endurance – the line means unholy fear – the line means blood and bit [sic] of flesh". I have no news for you, alas!'. A letter of 6 November 1917 reveals a different kind of response, this time to the drabness of his physical environment: 'The part of the world I am in is more than ugly – It is as flat as a pancake – here there is a little battered farm, there a stunted tree – Nothing else – Not a hill or wood or anything beautiful – I do not know if this kind of thing has any effect upon you but on me it has ...'. Unsurprisingly, nostalgia for England rears its head: on 29 November, he writes: 'What a wonderful place England is! Perhaps you have never noticed it; I never did before the war'.

Lowinsky's reaction to the horror and pity of war[9] found expression chiefly in poetry, to which there are a number of references in the letters. Ricketts took care to encourage his literary efforts ('Let one poem answer or contradict another ... the important thing is to write as many as you can and not necessarily to correct or amend'); and Lowinsky himself evidently took those efforts seriously (one of Ricketts's letters contains a reference to his protégé's wish to see some of them published in book form). Only one sonnet seems to have survived, however, and is thus worth quoting in full:

> While battle-thunder shook the ashen earth
> They spake, dear friend, of Death and thy sweet name,
> And dumb stood I, a thing for madman's mirth –
> Tortured and yet godless in each thought that came –
> My mind sought not of Memory to embrace
> an ever-fading image in thy stead.
> My heart was racing wild a-pace apace,
> I could not think of thee, so vital, dead –

I would not see thee lying, torn and still —
From deep within an unknown self I heard,
Strange voices whose hiss'd whisper 'kill and kill'
'Let vengeance be to thee a sacred word'
Then on I went the braver to the fray
In thee forgetting all, I went to slay.

(For a more vivid sense of the intensity — and uncertainty — of the twenty-six year old soldier's poetic attempts, one needs to see the poem as written (fig.5).)

fig.5 Poem by Thomas Lowinsky, 1918

Also extant are a small oil study of 1917, bitterly entitled 'The Soldier become Gravedigger' (fig.6), and a tiny and very poignant ink drawing of a British military cemetery in France, dated 1918 (cat.no.39). Otherwise, the only surviving image to reveal Lowinsky's visual, rather than literary response to the war is the sombre and doom-laden oil painting entitled 'The End of the World' (cat.no.5), executed in 1919, after the war had ended. He may — unlike his brother — have escaped severe physical injury; but there is little doubt that the First World War scarred Lowinsky for life. Deep depressions and black rages were to dog him for the rest of his life, and it is tempting to speculate that the quality of suppressed alienation so characteristic of his mature oeuvre was due, in part at least, to his experiences as a soldier.

Not all Lowinsky's artistic energy was taken up with wartime subjects. Some of his poems, the letters make clear, were concerned with quite other themes; while the prints he produced in 1917 on such subjects as Pandora or Auguste Rodin (cat.nos.32–34) were almost certainly a response to Ricketts's suggestion that he take up lithography in order to 'let off steam in some graphic medium', as well as to his advice on matters of technique. Ricketts's wartime letters to Lowinsky (far more of these survive than do those written by Lowinsky to Ricketts) give us plenty of insights, both into the nature of the relationship between the two men and into Lowinsky's wartime activities, interests and attitudes. One letter, for example, contains a criticism of an image of Hagai as being 'too small', and hence looking 'more like a reduction of a drawing than the drawing itself, done larger it could have had more accent and vividness in the washes'; another describes one of Lowinsky's lithographs as suffering from 'cramp owing to the scale upon which it is done. For small work a pen is better'. Elsewhere, in answer to Lowinsky's rebuttal of Tonks's exhortation to look at Manet rather than Botticelli, Ricketts agrees with Lowinsky's apparently poor opinion of Manet and the Impressionists. References to the worth of artists such as Blake and Calvert, to Russian icons and the fifteenth century School of Cologne, as well as the postcard reproductions Ricketts chose to send the young man (these range from – mainly Italian – Renaissance paintings through Blake to the Pre-Raphaelites, but also include a number of non-western images) testify to Ricketts's preferences, which Lowinsky would almost certainly have shared. There are indications, too, of the chronic lack of self-confidence that was to dog Lowinsky throughout his life ('Your fault is to

fig.6 **Study for the Soldier become Gravedigger** 1917, oil on canvas
$17\frac{1}{2} \times 11\frac{5}{8}$ (44.5 × 29.5) *Clare Stanley-Clarke née Lowinsky*

fig.7 Edmund Dulac **Thomas Lowinsky with Dog, Holding Baby Daughter Katherine** 1920 watercolour $11\frac{1}{2} \times 7\frac{3}{4}$ (29.3 × 19.7)
Private Collection

need too much praise as you go along'), countered elsewhere by Ricketts's admission that he had told Lowinsky's father 'that you are very talented'.

In fact, Lowinsky was the youngest member (hence his nickname 'Bengy') of a group of artists, writers and dramatists gathered around the charismatic figures of Charles Ricketts (1866–1931) and his lifelong companion, Charles Shannon. References in the letters to Edmund Dulac (see fig.7), Glynn Philpot,[10] Laurence Binyon and Sir Edmund and Lady Davis give an idea of that group's constituents; although equally, references to artists such as Nevinson and Epstein, to Cubism and Wyndham Lewis reveal an awareness on both men's parts of very different aesthetic alternatives.

Against the tide of Modernism, then, Ricketts adhered to an art that paid homage to the world of the Bible, to literature and classical mythology – the kind of subject-matter to which Lowinsky, too, was to remain loyal. Stylistically his canvases reveal an obvious debt to the painterly traditions of Renaissance Venice. These held little appeal for Lowinsky, however, who chose rather to emulate the strongly fin-de-siècle, Symbolist quality – Moreau, Beardsley and Burne-Jones are kindred spirits here – of Ricketts's line drawings for the theatre and for book illustration. (That Ricketts himself was aware of the dichotomy in his oeuvre is borne out by a diary entry of 12 July 1927, in which he refers to 'the dual personalities I have: the born ornamentalist one finds in the details of my theatre work, and the rather hectic improvisatoire of my paintings and bronzes. Both currents run side by side and refuse to blend. My painting refuses to face detail and certain kinds of invention, which Moreau and Burne-Jones have at their finger-tips. Once the pencil or point is in my hands I am incapable of breadth or suggestion and fall into filigree and can lapse into an almost Persian finick and finish . . . it is only in the theatre that these two tendencies merge'.[11])

The interest in the stage already shown by Lowinsky during his days as a student at Oxford, and which was to re-surface after the War was further fuelled by Ricketts's own activities as a designer for the theatre. (Their wartime correspondence even refers to a pre-war scheme, apparently never put into practice, whereby Lowinsky – presumably thanks to Ricketts's connections – was to design the sets and costumes for a play by Israel Zangwill. The famous actress Lillah McCarthy, a close friend of Ricketts, and wife of the playwright Harley Granville-Barker – who would later write the introduction for the 1923 edition of *The Merchant of Venice*, illustrated by Lowinsky, was to have played the leading role in the play.) As co-founder of the Vale Press in the 1890s, Ricketts was also an influential figure in the private press movement and in the trend towards the integration of text and image, in which Lowinsky's book illustrations of the 1920s and 30s play so significant a part. It seems, too, that Lowinsky shared Ricketts's interest in music, although he never allowed it to play as important a role in his life as did the older man.[12] Also noteworthy is Ricketts's lifelong passion for collecting artworks of all kinds – here too Lowinsky would follow suit, albeit in a more limited way.

It goes without saying, therefore, that Charles Ricketts was a vital formative

influence on Lowinsky. His initial interest in the young man, as was the case with so many of his young male protégés, may have been of a homosexual nature (and Lowinsky, with his dark hair and intensely blue eyes, was undoubtedly good-looking); but his concern for the latter's artistic education and the furtherance of his career was genuine. The two men remained good friends until Ricketts's death in 1931,[13] whereupon Lowinsky became one of the former's executors. (A year later Lowinsky would write the introduction to *Oscar Wilde: Recollections by Jean Paul Raymond and Charles Ricketts*, published by the Nonesuch Press.) A letter of 15 May 1941, that is to say, a full ten years after Ricketts's death, addressed to Brinsley Ford reveals the depth of Lowinsky's feelings for the older artist: '. . . as you know Charles Ricketts was my greatest friend, whose loss I will never quite get over'.

Ricketts's homosexuality had not prevented him from approving of Bengy's fiancée (he was later to become godfather to the couple's first child): 'We liked Ruth', he wrote. 'She is charming and intelligent and very much alive. I hope you will be very happy'. Ruth Hirsch came from an extremely affluent and cultured banking family of German-Jewish origin. Her father, Leopold Hirsch, a friend of Lowinsky's father, was a collector of some renown and her parental home at 10 Kensington Palace Gardens was graced with a number of family portraits commissioned from artists of repute (notably, a portrait of Ruth and her sister by Charles Shannon and portraits of Ruth's mother by Mancini and Sargent). Like many well-off young women with artistic leanings, she had studied at the Slade, only to abandon any ambition she may have had on her marriage to Tommy Lowinsky in 1919. Although Lowinsky did number several women painters among his friends (Nan Hudson, Ethel Sands, Nora Cundell and Ethel Walker, see figs.8 and 9, for example), he was clearly reluctant to risk any competition at home.

Ruth seems not to have minded, however, and contented herself with winning a considerable reputation as a magnificent cook and sparkling hostess (see cat.nos.57 and 59 for a discussion of the cookery books that resulted), first at 41 Kensington Square,[14] to which they moved in 1919, and later at Garsington Manor and The Old Rectory, Aldbourne, as well as the various houses they rented each summer. In his autobiography,[15] Francis Meynell recalled 'those charming characters Ruth and Tommy Lowinsky: Tommy a richly talented romantic painter, Ruth the perfect hostess, simple and enquiring in talk and highly sophisticated in such things as the planning of meals. At a small luncheon at their London house in Kensington Square I made a double acquaintance – with the wrist-befrilled Max Beerbohm and with Ruth's own invention of a delicious camembert ice'. An early, and now unlocated, portrait of Ruth by Lowinsky, painted during the couple's honeymoon (fig.10) shows a woman of character and determination. Her extrovert nature clearly complemented Lowinsky's more reticent one, and theirs was by all accounts an extremely happy marriage. Four children were born to them, two daughters and two sons, the eldest of whom, Martin, was to die tragically in the Second World War.

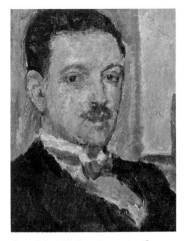

fig.8 Ethel Walker **Portrait of Thomas Lowinsky** *c*.1930, oil on canvas 15 × 12 (38.1 × 30.5) *Katherine Thirkell née Lowinsky*

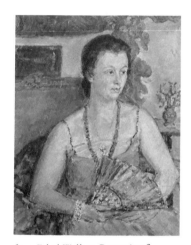

fig.9 Ethel Walker **Portrait of Ruth Lowinsky** *c*.1930, oil on canvas 29½ × 24 (75 × 61) *Katherine Thirkell née Lowinsky*

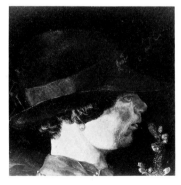

fig.10 **My Wife** 1919 (spring), oil on canvas(?) *current location unknown*

Everyone who visited the Lowinskys (and their guests included people as varied and eminent as the above-mentioned Max Beerbohm, Raymond Mortimer, Eddie Sackville-West, the Sitwells, Francis Meynell, Rebecca West, Karl Parker, James Byam-Shaw, Brinsley Ford, John Rothenstein and the artist friends already referred to) was impressed by the tastefulness and originality of their home environment. The interior furnishings mixed periods boldly and successfully, and objets d'art, also of different periods, were always laid out with exquisite taste. Sir Brinsley Ford, a friend of Lowinsky of many years' standing, has described[16] how 'at Aldbourne there was perfection in everything. You went from one room with pale grey walls into another with lilac grey walls … The furniture, the china, the cigarette boxes, the wall brackets, the statuettes all reflected his own extremely personal and enchanting taste'. The walls were adorned, not with Lowinsky's own paintings, but with a selection from his ever-growing collection of eighteenth, nineteenth and to a lesser extent, twentieth century British drawings, meticulously mounted and framed: 'No-one', writes Sir Brinsley, 'could design and order a mount with greater subtlety and his drawings were all shown to the greatest advantage in mounts on which he took infinite trouble'.

Sir Brinsley, fellow connoisseur and collector, has also given a vivid account of Lowinsky's activities and stature as a collector. '… Tommy inherited the tradition and instinct of Ricketts of appreciating quality in a drawing. Tommy always seemed to me to have a wonderful flair and sensibility in the drawings he chose. He was never influenced by a name and only bought what he considered beautiful. … Tommy confined himself to the British School but within these limitations he bought with remarkable discrimination … his walls were hung with some of the finest Romneys and Rowlandsons one could hope to find. A superb Gainsborough landscape, an early and thrilling Samuel Palmer, enchanting Fuselis, and always the example of the master which revealed the full play and subtlety of his genius. There were Stothards, and McEvoys and Conders and Wilkies and in fact all the English artists who could draw, many of them selected when the artists were thought much less of than they are today. By far the greatest proof of Tommy's true flair was to be found in the innumerable drawings by unknown artists, drawings which were all interesting and exciting as works of art. Tommy collected over a long period …'[17]. Mention should also be made of the fact that Lowinsky shared Degas's admiration for the drawings of Charles Keene. Sir Brinsley has recalled that guests arriving for dinner at Kensington Square used to assemble for drinks in a small room which was entirely hung with Keene's drawings.

Financial considerations (and perhaps, too, a desire for cohesiveness) may have persuaded Lowinsky to confine his collection to drawings of the British School, but within these constraints, as the above passage makes clear, his taste was catholic and wide-ranging. That he showed a fondness for the work of Samuel Palmer or the Pre-Raphaelites, for example, is not surprising when we consider the nature of his own oeuvre; that he was evidently partial to the work of an artist like Thomas Rowlandson, more so. However, Sir Brinsley has

plausibly suggested that Lowinsky admired artists whose work possessed precisely the bravura and robust earthiness his own productions so conspicuously lacked.

The affluence of Ruth's family clearly made it unnecessary for Tommy to earn his living by his painting. This was probably fortunate, as he seems to have been remarkably reluctant to expose his work to his friends', let alone public scrutiny, or to sell it. Conversely, though, he greatly minded the fact that his art received relatively little attention. Since this was partly at least due to the fact that he rarely publicized his artistic activities, it may be that the financial security he enjoyed acted as almost too effective a buffer against the outside world. A letter of 25 February 1941 to Brinsley Ford records his pleasure at the recent purchase by the Tate Gallery, Contemporary Art Society and National Museum of Wales of paintings by him (cat.nos.10, 18 and 3): 'Naturally I am delighted and flattered'. That this comes in the modest form of a postscript is also revealing.

Lowinsky kept his own productions carefully hidden in his studio, part of the house but firmly out of bounds to his family. He retreated here with an almost obsessive regularity, working every day from nine thirty in the morning until five o'clock in the afternoon, with an hour's break for lunch, after which he would go with Ruth for his daily constitutional in Hyde Park. Since he rarely talked about his own artistic activities and hardly anyone saw him at work, there are virtually no firsthand accounts of his working methods. Conclusions regarding these need, therefore, to be drawn chiefly from the completed works, from the two extant works that were left unfinished (cat.nos.23 and 29), from the occasional photograph showing a work in progress (see cat.nos.24 and 30) and from the significant fact that there are no preparatory sketches for any of the paintings.

Sir Brinsley noted that 'as a painter he was extremely modest and never showed his work to anybody. He worked with meticulous care, an expert craftsman, elaborating his complicated designs in a painstaking technique of his own'. Osbert Sitwell[18] in his catalogue introduction to the artist's 1926 exhibition observed how 'Mr Lowinsky's oil paintings are notable, too, for the same care expended on the choice of pigments that distinguished the Pre-Raphaelite paintings. These pictures will not crack, split and vanish as must so much modern painting'. William Rothenstein, also a friend of Lowinsky, wrote approvingly of his 'fastidious technique which allows of his painting *à premier coup* with a patient concentration peculiar to himself!'[19] The artist's eldest daughter, Katherine, recalls seeing her father working slowly across the picture surface, using the finest of brushes and the best linseed oil, starting from one corner and almost completing one area before moving on to the next, never – as far as she remembers – making any major changes. Her recollections are confirmed by the evidence mentioned above.[20] Although there are no preliminary sketches, he does seem to have mapped out his compositions in pencil with a firm, unwavering line, before embarking on the actual painting, sometimes also employing a grid framework (see cat.no.16).

fig.11 **Mr Wass the Local Gardener** 1921, oil on canvas *current location unknown*

His mature oil painting technique bears a striking resemblance to tempera in its dense, rather opaque surface qualities and minute attention to detail.[21] (In the same essay, Sitwell pointed out the affinities between Lowinsky's work and that of Joseph Southall, a Birmingham painter best known for his contribution to the revival of tempera painting in the 1920s.) Not surprisingly, each painting took many months, and sometimes well over a year, to execute, in spite of the fact that the artist never worked on more than one canvas at a time. Although Lowinsky could never therefore have been a prolific artist, it would have been quite in character for him to have destroyed any work he felt did not come up to scratch. With the notable and obvious exception of the portraits and landscapes, Lowinsky never worked from the model, preferring to rely on his memory and imagination.

As regards Lowinsky's stylistic development, it seems that the somewhat awkward handling of paint that one finds in the student works was gradually replaced by a greater technical finesse. The paintings of the immediate post-First World War period fall into two main categories: portraits, like 'My Wife' (fig.10), referred to above, or 'Mr Wass the Local Gardener' (fig.11), now lost, but in which – judging from photographs – there is a surprising freedom in the handling of paint (the bold unorthodoxy of the compositions, on the other hand, although inspired by Renaissance examples – notably Piero della Francesca's profile portraits of 'Federigo da Montefeltro, Count of Urbino and his wife Battista Sforza' of *c*.1465, clearly anticipates his later productions); and imaginative works like 'The Annunciation' or 'Daphne' (cat.nos.6 and 7), which are distinctly Symbolist in their choice of subject-matter and densely worked accumulation of decorative detail.

In paintings like 'The Fall of the Tower of Babel' and 'Helen of Troy', both of 1921 (cat.nos.8 and 9), however, surface ornament begins to be subordinated to an almost modernist clarity of design (labelled 'primitive' by some critics), a tendency that becomes ever more pronounced in the imaginative compositions of the later 1920s and early 1930s. Here as well is evidence of the original turn of mind that gives traditional subject-matter a new and unexpected lease of life, and qualifies Lowinsky to be seen as a genuine precursor of the Surrealist movement. William Rothenstein was the first to draw attention to this, in 1939: '... before it appeared in France, Thomas Lowinsky painted and perfected what might almost be called Surrealist pictures';[22] Allan Gwynne-Jones would also comment on this, in 1950.[23] The emphasis on enigmatic immobility and on a slightly sinister mystery lurking in the natural world allies these works by Lowinsky with those of British artists like Ithell Colquhoun or John Armstrong, who in the later 1930s found inspiration in European Surrealism. However, as Rothenstein and many others have pointed out, British Surrealism also has its roots in a native Romantic tradition, to which some of Lowinsky's work also undoubtedly pays homage. Yet his oeuvre remains impossible to categorize, for he also remains loyal to an almost academic iconographic tradition, however original and quintessentially modern his treatment of that tradition. Consciously or unconsciously (quite

The Flight of Queen Matilda from Oxford 1923, oil on canvas *current location unknown*

possibly the latter), Lowinsky expresses a peculiarly twentieth century ambivalence, ultimately perhaps unable to believe in the relevance to the modern age of these well-worn themes.

As for the portraits, these assume a dominant role only in the latter part of his career, that is to say, from the early 1930s onwards, 'Miss Cicely Hamilton' of 1926 (cat.no.14) being the only extant portrait produced between 1921 and 1932. The reasons for this change in preoccupation (which also coincides with the end of his productive period as a book illustrator) remain somewhat mysterious, although social pressure, possibly from his wife, to produce more conventionally acceptable images, may have partly been responsible. While the portraits are perhaps less strikingly original than the imaginative compositions, they too possess a quiet distinction. Obsessive attention to those physical features which render each individual unique, combined with penetrating psychological insight, an eye for unusual angles and a fascination with allusive and fragmentary accessory detail make these apparently understated images extremely memorable. (The portraits painted by Meredith Frampton in the same period offer an interesting comparison here.) Once again, William Rothenstein understood their significance: 'Lately Lowinsky has shown another kind of originality in a small number of women's portraits. These are done with an intense probing into shapes – of feature, hair and dress, uncommon even in the Flemish and Italian primitives'.[24] Sitters were either friends or acquaintances or – more frequently – hired models, usually women of an indeterminate age and quite lacking in the glamour usually associated with artists' models. We know their names, and the fact that Lowinsky treated them with scant consideration, making them pose, unflinching, in a cold studio for up to two hours at a time, but little else about them. That Lowinsky always chose to paint women, and women of this type, may perhaps say something about the deficiencies of his male ego. The other genre that Lowinsky worked with was landscape (fig.12; cat.nos.27 and 30). Although never a major preoccupation, he seems to have found the opportunity to work faithfully from nature during the family's summer sojourns at country houses a welcome relief from domestic responsibilities and from his other artistic activities.

It should come as no surprise by now to learn that Lowinsky had only one one-man exhibition during his lifetime, at the Leicester Galleries in London in early 1926. Osbert Sitwell wrote a complimentary introduction to the catalogue, in which he referred approvingly to Lowinsky's 'quiet dignity' and 'firm refusal to scream or stampede', his 'carefulness and precision in search of beauty', his 'eminence as a book illustrator, and designer for the stage', his affinities with the work of Gustave Moreau and 'Rossetti and his pre-Raphaelite brothers' and 'the new rendering of the primitive formula for landscape' in the background of his more important imaginative compositions. He went on to make a dig at the prevailing Bloomsbury ethos: 'The titles as well as the creative imagination of these pictures seem to show a feeling for, and knowledge of poetry and legend, which is, if one may say so,

fig.12 **Landscape (Cottage and Country Lane)** 1924, oil on canvas *current location unknown*

extremely gratifying in days when the poet is expected, for some reason or other, to know all about painting, music and history, the painter need know nothing of music, poetry or fable'.

Not many critics bothered to review the exhibition, but those who did responded favourably. In *Artwork 2* (1925/26), p.148, for example, we read the following: 'Equally remarkable in another way [to Albert Rutherston, with whom Lowinsky shared the exhibition space] has been the collection of paintings and drawings by T. Lowinsky, also shown at the Leicester Galleries. Though Lowinsky, like Rutherston, has had considerable experience in book illustration and in designing for the theatre, his is a more grave and serious temperament with quite another outlook on life. A clear, precise draughts-man with a lovely flow of line, a rhythmical designer who can record his conceptions in clear, high-pitched colour of admirable quality and suavity, Mr Lowinsky in paintings like 'Helen of Troy' and 'The Visitation' (cat.nos.9 and 13) succeeds in regaining much of the solemnity and clear-cut sincerity of the Primitives while he is yet eminently personal and distinctive in his style'.

On the outbreak of the Second World War, the Lowinsky family left London and moved first to relatives in Wales for a few months, and then to Garsington Manor (cat.no.30) near Oxford, famous for its association earlier in the century with Lady Ottoline Morell (whom they did in fact know socially), but which they rented for the duration of the War from an Oxford don named Heaton. The advent of another world war seems to have revived in Lowinsky's memory all the horror of the first one; the death of his eldest son, Martin, at Anzio in 1944 at the tender age of twenty-one can only have confirmed his worst nightmares. This, combined with his long-standing depressive tendencies, seems to have robbed Lowinsky of his will to paint, even to live. Accordingly, there are virtually no works produced after the outbreak of war. In 1945, their pre-war home in Kensington Square having been destroyed by bombs, the family moved to The Old Rectory, a fine eighteenth century building at Aldbourne in Wiltshire. In November 1946 Thomas Lowinsky was diagnosed as suffering from cancer of the lung and brain; by late April 1947, aged only fifty-five, he was dead. The words Sir Brinsley Ford wrote in his diary a day later stand as a fitting and moving tribute: '. . . I still find it hard to persuade myself that my old friend who understood beauty as few understand it is no more. He loved life and above all he loved Art and of all the people I have known few have been gifted with so great an Appreciation of it'.

A number of paintings by Lowinsky featured in group exhibitions throughout his career, both in this country and America. An article in *The New Statesman and Nation* of 2 August 1947 praised Lowinsky's painting of 'Garsington' to the skies when it was included in a mixed exhibition at the Leicester Galleries (see cat.no.30), but wrote far less favourably of his earlier works: 'He began by painting curiously unfashionable, mythological subjects in a Pre-Raphaelite style. (This was the more surprising as he had admirable taste which he revealed in forming a superb collection of English drawings of all periods.) Next he made a series of portraits in a very tight, exact manner derived

from Holbein and the early Flemings – vastly accomplished but, I think, too frigid to be expressive'. As William Rothenstein rightly observed in 1939, 'critics and connoisseurs only discover what they expect to find and the unusual qualities which distinguish Lowinsky's paintings are passed by'.[25]

Despite Lowinsky's inclusion in such exhibitions and despite the fact that his output as a book illustrator[26] won him high esteem in certain circles, the only other one-man show devoted to his work took place after his death, in the form of a memorial exhibition held at Wildenstein & Co. in London, early in 1949. This time it was another friend and colleague, Sir Francis Meynell, who penned the catalogue introduction. In it he wrote of Lowinsky's 'high humility', his 'exquisite and almost passionate coolness' and of his stature and integrity as a 'decorator' of books. 'Lowinsky's painting', he wrote, 'offers no challenges, protests no new cause, and yet – as I see it – belongs to no school. It is wholly different and wholly his, not because he invents a new language or constructs a novel idiom. It is his in the way that a fine writer will have a style manifestly his own within a language which is the common possession, or at least the common possibility of all ... As Lowinsky's art is not to be classified, so it will not date ... Lowinsky's pictures are as well founded, as well begun, having their roots in his imaginative, scrupulous, knowing and sensitive nature, as they are well "finished" by the diligent and comprehensive obligations of his art'.

One review of the exhibition, in *Apollo* (February 1949), was somewhat equivocal: 'Lowinsky's work has a decorative quality and the portraits an individuality of great charm. His book illustrations with their sense of the harmony between typography and decoration were, to me, the most fundamentally sound aspect of an art which otherwise did not seem ever entirely to find itself. It may be that he tried too many methods in his search. I had a feeling that he would have given something entirely satisfying as a mural artist, for the flatness and two dimensional decorative values of many of the paintings would have fulfilled the conditions ideal to mural art. The portraits, too, just stopped short of being entirely satisfying, but they had an elusive beauty: they felt so self-contained as a fine portrait should, as though the distinctive personality of the sitter had invested paint and canvas. Perhaps that is the highest praise for portraiture'.

Other reviews were more wholehearted in their praise. T. W. Earp in the *Daily Telegraph*, described Lowinsky as 'an artist of comparatively small output and of rare distinction ... a painter of imagination and one of art's independents', who achieved 'a sterling clarity of line and colour ... the fever of modern movements left him unaffected. Tradition sufficed him for technique and his own poetic spirit and the world of legend gave him his themes'. The review published in *The Times* on 25 January 1949 referred to his 'incredibly careful and conscientious ... craftsmanship': '... essentially he was a poetic illustrator with a remarkable and highly individual idiom strangely poised between Pre-Raphaelite and surrealist imagery'.

A book on *Portrait Painters* published in 1950 by an old friend of Lowinsky, the

painter Allan Gwynne-Jones[27] includes an astute appraisal of his talents, and is thus worth quoting almost in full:

> A friend, glancing at these reproductions [of Lowinsky's 'Miss Brady' and 'Miss Avril Turner' cat.nos.22 and 28], expressed surprise at the inclusion of Mr Lowinsky's portraits 'as they seemed so different from other modern paintings'. I resisted the tempting and obvious reply, and suggested that he should look again at Van der Weyden or Dirk Bouts; for the fact that most portrait painters have followed the Venetian tradition does not make an earlier tradition less valid, nor is it, when it is thoroughly assimilated, less likely to produce new and original works of art.
>
> Those who are familiar with Mr Lowinsky's early imaginative paintings ... may have noted that Mr Lowinsky in his execution and in the sort of forms he employs – particularly his use of small objects, sea-shells, broken fragments of stone and so on, as an enrichment of plain surface – anticipates by many years the work of the 'surrealist' painters. This is insufficiently admitted. Further, his originality is rendered more striking if we remember the period in which these pictures were painted – the period of Steer-McEvoy - the New English Art Club and Impressionism – and more so still if we bear in mind that the chief exponents of English Impressionism were among Mr Lowinsky's personal friends. Though no one could be less of an Impressionist than he, it is remarkable that, despite his preoccupation with design, his frank 'literary' interest, and his love of intensely realized detail, he should nevertheless be able to maintain a general unity of tone – though this tone is not of a realistic kind.
>
> To combine two such usually divergent views is rare. But I think it is even less often that we find an artist with such uncommon gifts who can, as he grows older, also bring them to bear on natural objects – on living people and on landscape. There is no break in his work; his vision of the imaginary world and of the actual is fundamentally the same, and it is stated in analogous terms; it has developed and deepened, but it has not changed. Mr Lowinsky's work is distinguished by a very personal sense of design, by a delicate and distinguished use of colour, and by an intensity of drawing ...

The only other retrospective exhibition of Lowinsky's work was held at the Graves Art Gallery in Sheffield in 1981, where it met with considerable popular interest. A review of this in *The Times Literary Supplement* of 16 January 1981 called Lowinsky a 'serious ... versatile ... and striking artist'; while the *Burlington Magazine* (February 1981) referred to him as 'a remarkable and neglected artist, some of whose incisive portraits of women rank with those of Freud, early Gertler and Gwen John'. Thomas Lowinsky has surely been neglected too long ...

Notes

1 The family fortunes were to suffer a decline caused by the crash in the South African diamond industry; yet even before this, the father withheld funds from the young Thomas Esmond so that his student days were by no means affluent.

2 During the war, however, Tonks did not hesitate to enlist his help in making architectural drawings at a Dressing-Station (see Hone, J. *The Life of Henry Tonks*, p.143 for this rather tantalizing reference).

3 This has been described by Bruce Laughton (in *P.W. Steer*, p.82) as 'a sad, slow, but sensitive study of a quiet personality' – which probably tells us more about Steer in the latter part of his career than about the, by all accounts, highly vivacious Mrs Lowinsky! See also McColl, D.S. *Life, Work and Setting of Philip Wilson Steer*, pp.103–4 for Mrs Lowinsky's account of the experience of being painted by Steer.

4 McColl p.134.

5 McColl p.134.

6 Paul Nash was to become a close friend of Lowinsky only much later, when they both lived in Oxfordshire during the Second World War.

7 Jenkins, D.F. 'Slade School Symbolists' in *The Last Romantics*. London: Barbican Art Gallery, 1989, pp.71–6.

8 The letters Ricketts wrote to Lowinsky still belong to the latter's family; Cecil Lewis's *Self-Portrait taken from the Letters and Journals of Charles Ricketts RA* contain many of these letters, as well as a number of diary entries which reveal Rickett's strong sympathy with the younger man's experiences – see pp.277, 285, 298). The few letters from Lowinsky to Ricketts that have survived are housed in the manuscript section of the British Library.

9 The poet Wilfred Owen was apparently a friend of Lowinsky.

10 There are certain affinities between Philpot's imaginative figure compositions of the 1920s (consider, for example, 'The Repose on the Flight into Egypt' of 1922) and those painted by Lowinsky. Both treat traditional subjects in an unusual and sometimes surreal fashion.

11 Lewis, C. *Self-Portrait*, p.379.

12 The artist's sister recalls that Lowinsky used to play his own compositions on the piano; while composers William Walton and Constant Lambert were to feature among his acquaintances.

13 See Lewis, C. *Self-Portrait*, p.xiii for a description of the somewhat macabre circumstances of Ricketts's funeral, and Lowinsky's part in them.

14 Lowinsky bought the house in Kensington Square largely because Edward Burne-Jones had lived and worked there.

15 Meynell, F. *My Lives*, pp.199–200.

16 This, and the quotations that follow, all come from a diary entry of 25 April 1947, the day after Lowinsky's death. Excerpts from this, and from the letters Lowinsky wrote to Brinsley Ford during the Second World War are printed here with the kind permission of the author.

17 In the 1950s, after Ruth Lowinsky's death, the collection was sold virtually intact to the Paul Mellon Center for British Art at Yale, where it is still housed.

18 See pp.60–1 for further details of Lowinsky's association with the Sitwells.

19 Rothenstein, W. *Since Fifty: Men and Memories 1922–1938*, p.75.

20 Although this is obviously an unusual method of working, it was one shared by a number of Lowinsky's contemporaries, notably Stanley Spencer and John Armstrong.

21 So close is the resemblance to tempera that a number of Lowinsky's paintings in public collections have been incorrectly catalogued as being executed in that medium.

22 Rothenstein, p.75.

23 Gwynne-Jones, A. *Portrait Painters, European Portraits to the end of the 19th Century and English 20th Century Portraits*, p.37.

24 Rothenstein, p.75.

25 Rothenstein, p.75.

26 See p.56ff for further details.

27 Gwynne-Jones had painted Lowinsky's portrait some twenty years earlier.

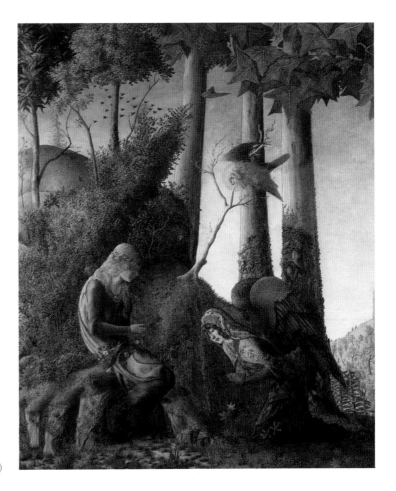

The Annunciation 1920 (cat.no.6)

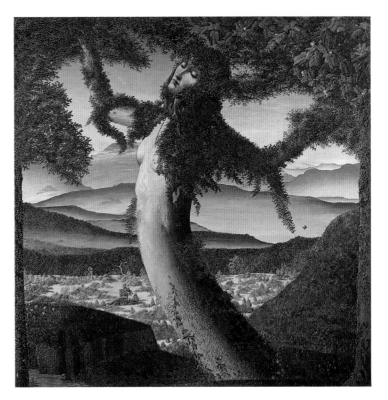

Daphne 1921 (cat.no.7)

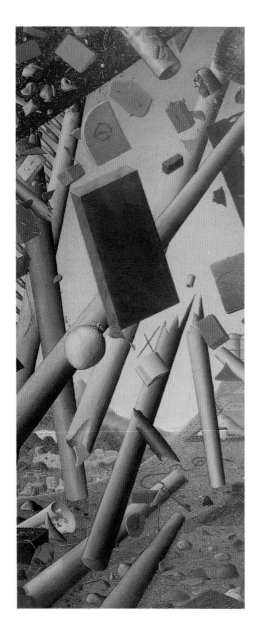

Helen of Troy 1921 (cat.no.9)

The Fall of the Tower of Babel 1921 (cat.no.8)

The Dawn of Venus 1922
(cat.no.10)

Sappho 1923 (cat.no.11)

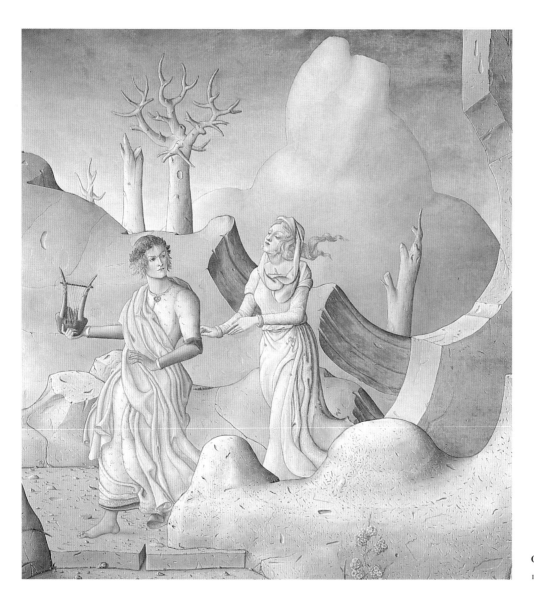

Orpheus and Eurydice
1924 (cat.no.12)

Miss Cicely Hamilton, the Authoress
1926 (cat.no.14)

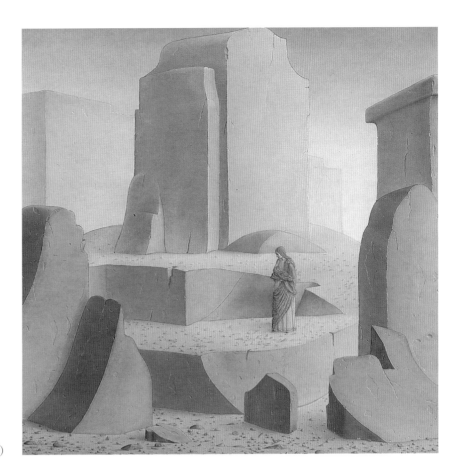

Hagar in the Wilderness 1926 (cat.no.15)

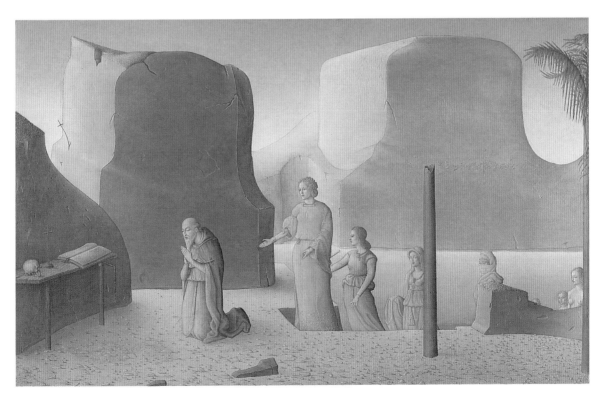

The Temptation of St Antony 1927 (cat.no.16)

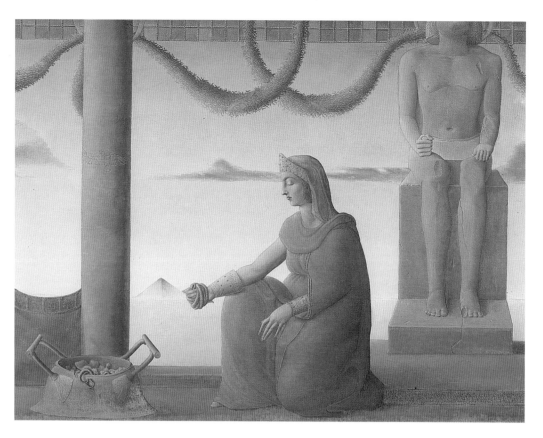

Cleopatra 1928 (cat.no.17)

The Breeze at Morn 1930 (cat.no.18)

The Mask of Flora 1931 (cat.no.19)

Miss Serinka Negrearnu 1932 (cat.no.21)

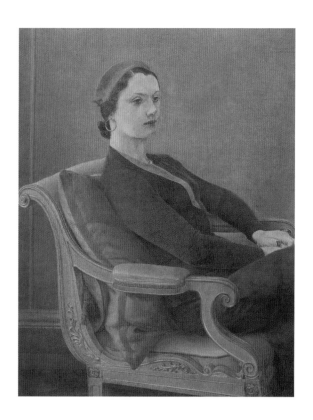

Mrs James Mackie 1935 (cat.no.25)

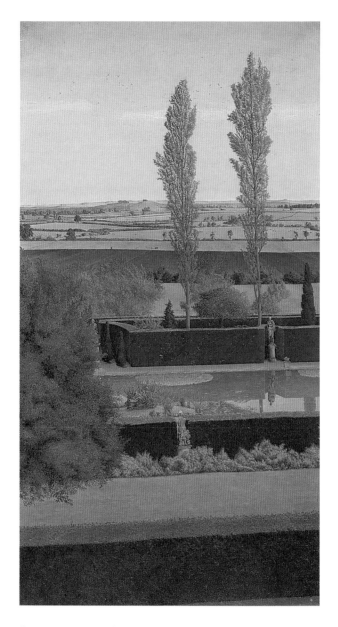

Garsington 1939–45 (cat.no.30)

Catalogue

Catalogue note

Measurements are given in inches followed by centimetres, with height preceding width, and refer to the unframed image size. Full bibliographical details can be found in the Bibliography. Certain abbreviations have been used in the entries and these are listed below:

b.c.	bottom centre
b.l.	bottom left
b.r.	bottom right
b/w	black and white
Carnegie Inst.	Pittsburgh, Carnegie Institute. *International Exhibition of Paintings* (annual)
CAS	Contemporary Art Society
EXH	Exhibited
Graves AG	Sheffield, Graves Art Gallery. *Thomas Lowinsky (1892–1947)*, 1981
Gwynne-Jones	Gwynne-Jones, Allan. *Portrait Painters, European Portraits to the end of the 19th century and English 20th century Portraits.* London: Phoenix House, 1950
Imperial Gall.	London, Imperial Gallery of Art, Imperial Institute. *Paintings, Drawings and Sculpture by Artists resident in Great Britain and the Dominions* (annual)
Leicester Galls.	London, Ernest Brown and Phillips, The Leicester Galleries. *Paintings and Drawings by Thomas Lowinsky 1892–1947*, 1926
LIT:	Literature
l.l.	lower left
l.r.	lower right
NEAC	New English Art Club, London
RA	Royal Academy of Arts, London
REPR:	Reproduced
t.r.	top right
Wildenstein	London, Wildenstein & Co. *Memorial Exhibition of the Work of Thomas Lowinsky (1892–1947)*, 1949

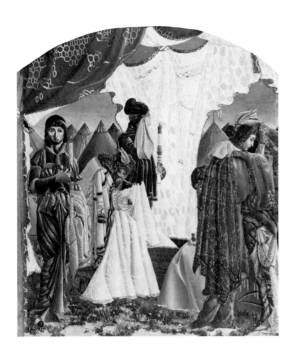

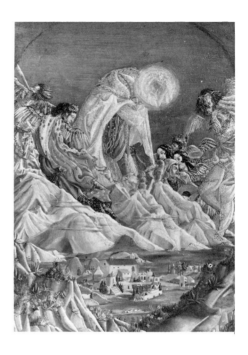

1 **Salomé** 1914
Oil on canvas $37\frac{1}{8} \times 31\frac{1}{2}$ (95.3×80)
Inscribed: 'TEL [in monogram] 1914' b.l.; 'Salomé' (?) on
back of frame
Justin Lowinsky

The subject of this painting comes from the New Testament.
King Herod, already lusting after his step-daughter Salomé,
holds a banquet at which the beautiful young woman dances
so lasciviously that he promises to grant her whatsoever she
might wish. On the instructions of her mother Queen
Herodias, who seeks revenge on the Baptist for his reproval of
Herod for marrying his brother's wife, Salomé demands that
his head be presented to her on a charger (or platter).
Although dismayed by the request, Herod orders his execution.
The scene being presented here appears to be Salomé's
presentation of the head of John the Baptist to Herodias,
although it is difficult to identify the main protagonists with
any certainty. The subject (and particularly the dance of
Salomé) had been a favourite one with the Symbolist painters
of the late nineteenth century both for its erotic charge and for
the opportunity it provided for depicting 'oriental' splendour
and decadence: Gustave Moreau's series of 'Salomé' images of
the mid-1870s are perhaps the best-known examples here.
Significantly, though, Lowinsky has chosen to underplay the
erotic element in the story, creating instead a scene of frozen
movement and theatrical poses, in which the drapery of
clothes and tents seems as anthropomorphic as the human
figures themselves.

2 **Touch the Mountains and They shall Smoke** 1914
Oil on canvas $23\frac{1}{2} \times 17\frac{1}{2}$ (59.7×44.5)
Inscribed: 'TEL [in monogram] 1914' l.l.; 'Touch the
Mountains and They shall Smoke by T.E. Lowinsky' (in
capitals) on back of canvas
R. L. E. Thirkell and T. H. Nayani

Lowinsky was not a religious man, although as several of his
images – including this one – bear witness, he was quite
prepared to pay homage to an iconographic tradition steeped
in the Christian faith. Here he endows the features and
costumes of his angels with a distinctly exotic, middle eastern
quality, although the landscape in the foreground seems more
reminiscent of Italy. Significantly, perhaps, bearing in mind
Lowinsky's Jewish origins, the features of the central God figure
are left suggestively vague. The discrepancy in scale between
the celestial figures and their landscape setting (which one also,
of course, finds in pre-Renaissance religious images) adds to the
slightly surreal quality of the painting. Although, as with most
of his pre-war productions, the colour and handling of paint in
this work is considerably cruder than in his later works (the
puffs of smoke emanating from the mountains in the centre,
which presumably give the painting its title, are rather too
solid-looking for comfort!), it nevertheless carries a certain
conviction.

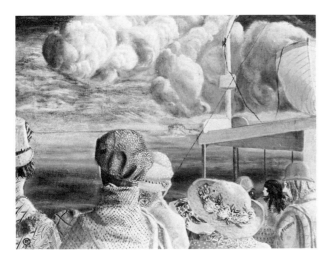

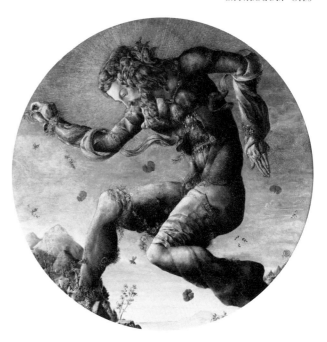

3 Belgian Emigrants 1914 1914
Oil on canvas 17 × 22 (43.2 × 55.9)
Inscribed: 'TEL [in monogram] 1914' b.l.
EXH: Wildenstein (7)
National Museum of Wales, Cardiff

This early oil painting is unique among Lowinsky's extant works for treating a topical subject: namely, the influx of Belgian refugees to England after the invasion of Belgium by the Germans in 1914. Like all the artist's works, however, it is striking for its unusual composition, in particular here the curious way in which figures are truncated; while the angle from which they are seen encourages the viewer to empathize with their emotion as they seem to gaze intently at the retreating shoreline of Belgium – or alternatively, at the coastline of the country that is to shelter them. The handling of paint in this work, in common with other works from this period, is far more emphatic and robust, if somewhat cruder than in Lowinsky's later works. The painting was bought from the artist in 1941.

4 Homage to Greece and Italy 1914–15
Oil on canvas 34½ (87.6) diameter
Inscribed: 'TEL [in monogram] 1915' l.r.
EXH: Wildenstein (2); Graves AG (as *God walking over the World*)
LIT: *Daily Telegraph*, 1949
Justin Lowinsky

This painting, like cat.no.3, apparently worked on while Lowinsky was already in the army, is one of the most bizarrely memorable of all his imaginative figure compositions, even if it remains rather less resolved than most of his more mature works. Although the painting's title remains slightly puzzling, it does, as a reviewer of Lowinsky's memorial exhibition put it, 'indicate the classic sources of the artist's inspiration': barely contained by the circular canvas, the bearded, muscular and ultimately enigmatic figure straddles the landscape like a colossus (and Lowinsky had travelled in Greece, and very likely seen the famous Colossus of Rhodes in the summer of 1913); while the angelic beings tangled in his hair, as well as the meticulously detailed drapery, flower and landscape forms hark back to the Italian Renaissance, mediated by the influence of the English Pre-Raphaelites and European Symbolists. As the halo-like emanation, as well as the title given to the painting when it was shown in Sheffield (see above) suggests, the central figure may well have Judaeo-Christian implications too. It seems that Lowinsky's fellow soldiers referred to one of his paintings as 'Jumping Jesus'; if so, this may well be the work in question!

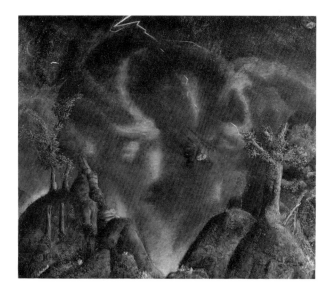

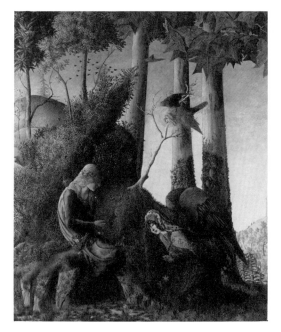

5 The End of the World 1919
Oil on canvas 24½ × 29½ (62.2 × 74.9)
Inscribed: 'TEL [in monogram] 1919' l.r.; 'The End of the
World by T.E. Lowinsky' (in capitals) on back of canvas
EXH: NEAC, Dec. 1920 (134); Leicester Galls. (26);
Wildenstein (4)
Private Collection

The pessimistic nature of this painting is without doubt a
response to the traumatic experiences Lowinsky had just
undergone as a soldier in the First World War. Although details
such as the lightning flashes or the winged angel heads in the
centre and top righthand corner of the composition are
iconographically related to a medieval Byzantine tradition
(mediated perhaps by William Blake), and the broken pillar
links the painting to Romantic 'end of empire' images by artists
such as Turner, John Martin or Thomas Cole, the desolation
and devastation of the natural world depicted here has strong
affinities with the wartime images of fellow Slade student Paul
Nash (see, for example, 'We Are Making a New World' of 1918).
Colours are brooding and sombre, predominantly reddish-
browns, dark browns and greens, illuminated only by the
dramatic blue and orange-yellow lightning flashes. Only
gradually do significant details emerge from the general gloom:
the flames at the bottom of the painting that merge cunningly
with the foliage, the watchful eyes on the central angel's wing.
At the heart of this painting, and quite literally at its centre lies
a void.

6 The Annunciation 1920
Oil on canvas 29 × 25 (73.7 × 63.5)
Inscribed: 'TEL [in monogram] 1920' l.l.
EXH: NEAC, summer 1921; Leicester Galls. (24, lent by
Ernest R. Debenham; bought by latter, 1920); Wildenstein
(14, lent by Leicester Galls.)
REPR: *Studio* 134: 177 Dec. 1947
Clare Stanley-Clarke née Lowinsky

Of all Lowinsky's paintings, this is the one that pays the most
obvious homage, in terms of style and subject-matter alike, to
the Italian Renaissance (consider, for example, Filippo Lippi's
'Annunciation' in the National Gallery), albeit mediated by a
strong awareness of the mannerisms of late nineteenth century
Symbolist art. Both Mary and the archangel Gabriel (who, it
must be said, looks far more feminine than in most renderings
of the Biblical scene!) are shown as if immobilized and
overawed by the portentousness of events, as the Holy Spirit, in
the form of an anthropomorphized dove hovers up above.
Colours are limited in range, comprising mainly deep greens,
blues and brown earth tones, but achieve an almost jewel-like
resonance; detail in the depiction of the natural world, though
clearly rooted in an empathy for and understanding of specific
organic forms, remains distinctly stylized (rather in the
manner of Gustave Moreau), forming an intricate, highly
ornamental and very satisfying pattern across the picture
surface. This interest in achieving a decorative overall effect is
continued in Lowinsky's choice of frame. (As will become
evident from looking at the works on display – nearly all of
them in their original frames, this was an area upon which the
artist lavished considerable care.)

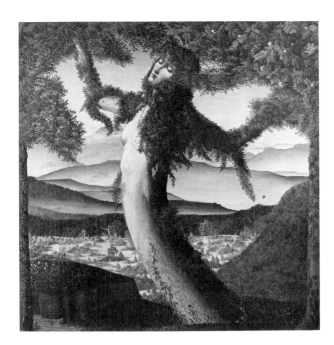

7 **Daphne** 1921 (spring)
Oil on canvas $27\frac{1}{4} \times 27\frac{1}{4}$ (69.2×69.2)
Inscribed: 'TEL [in monogram] 1921' b.l.
EXH: *The International Society of Sculptors, Painters and Gravers, 28th*
London Exhibition, Grafton Galleries, London, 1922 (186);
Carnegie Inst., 1927 (241) (didn't compete for honours
because executed too early to be eligible – same applies to
all other paintings included in other Carnegie exhibitions);
Leicester Galls. (12); Wildenstein (5)
Clare Stanley-Clarke née Lowinsky

Although similar to 'The Annunciation' (cat.no.6) in its range
of colour and intricacy of surface detail, this painting takes its
inspiration from pagan mythology. The story of Apollo and
Daphne has always been a popular one with artists, if only for
the technical challenges it offered. According to Ovid, it was
Cupid's spite that caused Apollo the sun god to become
enamoured of Daphne, daughter of the river god Peneus,
without Daphne reciprocating his feelings. When Apollo gives
chase, Daphne prays to her father to save her, whereupon she is
promptly metamorphosed into a laurel tree. Traditionally, the
story symbolizes the triumph of Chastity over Lust, although
the relish with which it is often depicted, with the emphasis on
the excitement of the chase and the drama of the transform-
ation (consider, for example, the seventeenth century sculptor
Bernini's famous rendering of the scene in marble) makes one
question the artists' true motives. In Lowinsky's version,
however, there does indeed seem to be a quality of chasteness,
albeit resigned and slightly melancholy, in the figure of
Daphne, which perhaps links her to the figure of the Virgin
Mary in the previous painting; while the utter stillness of
Lowinsky's Daphne contrasts strongly with the emphasis on
dynamic action characteristic of most other treatments of the
subject.

8 **The Fall of the Tower of Babel** 1921 (autumn)
Oil on canvas $35\frac{1}{4} \times 14\frac{3}{4}$ (89.5×37.5)
Inscribed: 'TEL [in monogram] 1921', l.l.
EXH: Friday Club, 1922; Leicester Galls. (17) (N.B. special
mention in catalogue introduction); Wildenstein (6)
Clare Stanley-Clarke née Lowinsky

The story of the Tower of Babel is to be found in the book of
Genesis. In their arrogance, the people of Babylon had decided
to construct a city complete with a tower 'with its top in the
heavens'. To humble their pride, God confused the people's
language so that they no longer understood each other (hence
the modern term 'babble'), and scattered them over the face of
the earth, leaving the edifice unfinished. Most visual represent-
ations of the story (notably Pieter Bruegel the Elder's 'The
Tower of Babel' of 1563) depict the tower as a ziggurat-like
structure; the idea of a confusion of tongues is usually
indicated by the portrayal of different ethnic types. In marked

contrast to this, Lowinsky has chosen to depict the moment of the tower's fall or destruction. This painting is unique among Lowinsky's imaginative compositions for its narrow vertical format and the fact that it is virtually unpeopled. References to human activity, however, abound, in the form of a furled-up town plan, a ladder, a bucket, fragments of sculpture and so on, and although easy to overlook, lend the painting much of its poignancy. Nor should one fail to notice what may well be the symbolic hand of God in the top righthand corner of the composition. Nevertheless, the most striking aspect of this painting is its deployment of almost abstract geometric shapes, making it the most obviously modernist in orientation of all Lowinsky's works, and the one to which Osbert Sitwell's mention of Lowinsky and Fernand Léger in the same breath does indeed seem appropriate. Lowinsky may not have allied himself with the Modern – or indeed, any other movement; but he was certainly well aware of contemporary trends and developments.

9

9 Helen of Troy 1921 (repainted Feb. 1925)
Oil on canvas $28\frac{1}{2} \times 21\frac{1}{4}$ (72.5 × 54)
Inscribed: 'TEL [in monogram] 1921' l.l.
EXH: Grosvenor Galleries, 1922; Leicester Galls. (10);
Carnegie Inst., 1927 (253, repr. in b/w); Wildenstein (8);
Graves AG
LIT: *Artwork* 2 (1925/6) p.148
Justin Lowinsky

As in 'Daphne', the focus of this painting is on a single female figure placed almost hieratically in the literal centre of the composition. (The dramatic frontal pose may, in this case, have been inspired by the sculpture of a Carthaginian priestess, a postcard reproduction of which Lowinsky brought home with him from his travels in 1913.) Although both figures share an enigmatic stillness, the relationship of figure to background has changed dramatically. Helen's hair may still be organically sinuous in its complex arabesques, but the landscape against which she proudly stands is curiously empty, devoid of any biomorphic detail. What recognizable forms there are refer instead to the destruction of cities and the frailty of human endeavour – and appropriately so, for a story in which female beauty wreaks terrible havoc. In Greek mythology, Helen was the daughter of Leda and Jupiter (or Zeus), and wife of Menelaus, King of Sparta. Famed for her beauty, hers was 'the face that launched a thousand ships', for when the Trojan prince Paris abducted her to Troy in her husband's absence, the

latter initiated the Trojan war by mounting an expedition to recover her. Most earlier renderings of the subject show the rape of Helen as a group scene of violent struggle; in Lowinsky's painting, only a lone arrow and the weapon motifs on the border of Helen's cloak allude – quietly, but effectively – to combat. Unusual too is the curiously asexual quality of his main protagonist. The much paler and subtler hues of the painting, while still limited in range, mark a new development in the artist's use of colour.

10 The Dawn of Venus 1922
Oil on canvas $30\frac{1}{2} \times 28\frac{1}{2}$ (77.5 × 72.5)
Inscribed: 'TEL [in monogram] 1922' b.l.; 'The Dawn of
Venus by T.E. Lowinsky' on back
EXH: Leicester Galls. (25); NEAC, Nov. 1926 (225); Carnegie
Inst., 1927 (245); Imperial Gall., 1931 (139); Wildenstein (16)
(N.B. special mention in catalogue introduction)
LIT: Gwynne-Jones p.37
REPR: *Studio* 122, Sept. 1941, p.68
Tate Gallery

Like many of Lowinsky's mythological and biblical compositions, this painting is strongly indebted to classical antiquity and the art of the Renaissance: here both the title of the work

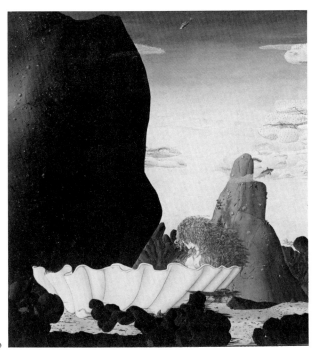

10

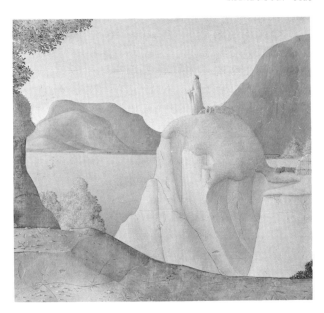

11 Sappho 1923

Oil on canvas $18\frac{3}{16} \times 20\frac{1}{8}$ (46.2×51)

Inscribed: 'TEL [in monogram] 1923' b.l.

EXH: Leicester Galls. (9); NEAC, 1927 (135); Wildenstein (19, lent by the Tate Gallery); Hull, Middleton Hall, University of Hull. *Surrealism in Hull*, 1989, cat. p.25

Ferens Art Gallery, Hull City Museums and Art Galleries

and the association of Venus with the large scallop shell inevitably bring to mind Botticelli's famous 'Birth of Venus' of c.1485. As always, however, Lowinsky interprets a traditional theme in a distinctively quirky and unexpected way. Instead of showing the goddess rising triumphantly from the sea (according to the early Greek poet Hesiod, she was born from the foam produced by the genitals of the castrated Uranus when they were cast upon the waters) surrounded by her retinue of nymphs and propelled to shore by gentle breezes, he has chosen to depict her motionless and solitary, crouched in her shell, inscrutable in her expression; only gradually does it become obvious, from the wealth of minute detail (starfish, sea urchins, fishes and so on) that she is actually resting on the sea floor. This painting, one of three owned by the Tate Gallery, was purchased from the artist in 1940 via the Knapping Fund during the period of Sir John Rothenstein's directorship. (Having been close friends for some years – during World War Two, the Rothensteins lived for a while with the Lowinskys at Garsington Manor before moving to a nearby cottage found for them by the Lowinskys – that friendship came to an abrupt and rather bitter end soon after this, largely as the result of domestic misunderstandings.)

This painting is inspired not so much by previous visual representations of classical myth and legend, but by literary sources. Sappho was a Greek lyric poet born in about 612 BC into an aristocratic family of Mytilene. Her sexual proclivities led to disapproval from the society of her day, and she spent a period of exile in Sicily. Returning to her native island of Lesbos (which explains the origin of the term lesbian), she became the head of a small college of women, or *thiasos*, which was traditionally dedicated to Aphrodite and intended to perfect young women in preparation for marriage. The poems Sappho wrote in Aeolic dialect, for which she has become notorious, express a whole gamut of emotional responses to the charms of one or other of her pupils. In fact, most of the poems, which originally formed nine books, were lost, while we know very little about her life – and nothing of her death. The legend, stemming largely from Ovid and the New Comedy, that she threw herself over a cliff for love of Phaon, nevertheless persists – as Lowinsky's painting, showing her on the point of doing precisely this, bears witness. All is still, however, in the lull before violent action. The extraordinary rock formation on which Sappho stands, her poet's lyre set aside, has a sinister, almost anthropomorphic presence. A member of the artist's family has plausibly suggested that the dramatic landscape of the coastline south of Naples, which Lowinsky often visited, acted as an inspiration here. The painting was purchased from the artist by the Duveen Fund in 1927; housed at the Tate Gallery until 1949, it was then presented to the Ferens Art Gallery.

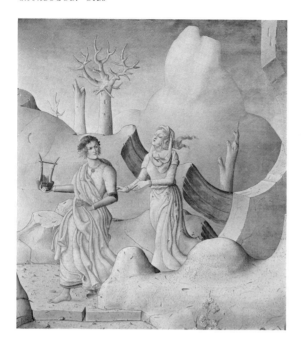

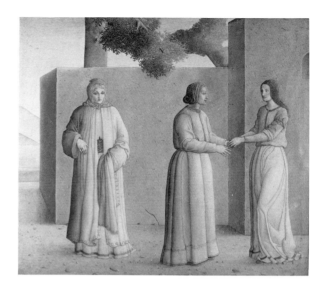

12 Orpheus and Eurydice 1924

Oil on canvas 29 × 27 (73.7 × 68.6)
Inscribed: 'TEL [in monogram] 1924' l.l.
EXH: Leicester Galls. (23); Imperial Gall., 1929 (175, priced at £200); Carnegie Inst., 1933 (163, b/w.pl.24); Wildenstein (21)
Private Collection

Once again, the subject for this painting is taken from Greek mythology. According to Ovid's *Metamorphoses*, Orpheus was a Thracian poet, renowned for his musical prowess (hence the lyre in his hand and the crown of laurel on his head – this being the reward for victory in ancient Greek contests of poetry and song), who married Eurydice, a wood nymph. When Eurydice died prematurely, of a snake bite, Orpheus descended into the Underworld, where through the power of his music, he persuaded Pluto to allow his beloved to follow him back to earth – on the strict condition, however, that he did not turn to look at her before they reached their destination. The failure of Orpheus to stick to his part of the agreement lost him his wife – this time for ever. (He was later to come to a gory end, torn apart by frenzied Maenads, female followers of Bacchus.) Lowinsky has chosen to depict the episode in the story where Orpheus, having reclaimed his wife, is on the very point of looking back at her as they emerge from the mouth of Hades. Eurydice, with a look of frozen horror on her face, extends a hand to restrain him. The truncated branches of the stunted trees in the background seem to echo her half-warning, half-pleading gesture; while the fissure in the rock just below the feet of Orpheus speaks tellingly of the impending disaster. Shapes in this painting become ever more dramatic, and ambiguous, so that architectural and geological, geological and meteorological (is the large presence in the background a mountain or a cloud?) forms merge into each other.

13 The Visitation 1925

Oil on canvas 26 × 30 (66 × 76.2)
Inscribed: 'TEL [in monogram] 1925' l.l.
EXH: Leicester Galls. (11); Imperial Gall., 1930 (185); Wildenstein (9)
REPR: *Artwork* 2 (1925/26) p.143
LIT: *Artwork* 2 (1925/26), p.148
R. L. E. Thirkell and T. H. Nayani

The Gospel according to Luke relates how the Virgin Mary visited her cousin Elizabeth soon after the Annunciation (see cat.no.6), an occasion of mutual rejoicing, since Mary had conceived and Elizabeth was in the sixth month of pregnancy after a lifetime of barrenness (her child was to be John the Baptist, see cat.no.1). Although Lowinsky abides by tradition in placing the scene of the women's meeting in the open, outside the house, presumably of Zacharias, Elizabeth's husband and in showing Elizabeth as conspicuously older than Mary, the solemn manner in which they greet each other falls somewhere between the formal bow common in medieval renderings of the subject and the embrace usually depicted in Renaissance images. Indeed, the rather heavy, sculptural treatment of the drapery and features, and the general *gravitas* of mood recalls the work of historically transitional sculptors such as Nicola Pisano. The schematized setting, on the other hand, creates a feeling of irreality and insubstantiality, almost of a stageset (note, for example, the ambiguity of space created by the jutting tree form). The presence in the painting of a third figure is unusual and slightly puzzling, in that the two women are usually shown either alone or accompanied by their respective husbands. Since this third figure (on the left of the composition) is clothed rather differently to the others and is somewhat asexual in its shape, it is just possible that it is one of these two men (perhaps Zacharias, who, as high priest of the Temple, is usually shown wearing vestments); on the other hand, since the features do look distinctly feminine, it may be either Mary Cleophas or Mary Salomé, occasionally shown in attendance.

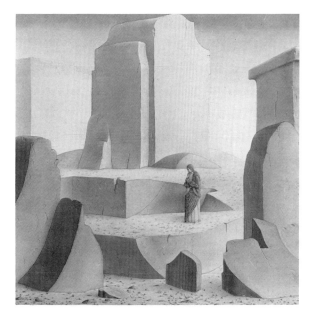

14 Miss Cicely Hamilton, the Authoress 1926
Oil on canvas 9 × 10 (22.9 × 25.4)
Inscribed: 'TEL [in monogram] 1926', b.r.
EXH: Leicester Galls. (18); Kettering Art Gallery, Aug. 1946;
Stalybridge, Astley Cheetham Public Library and Art
Gallery. *19th Annual Exhibition of Contemporary Art*, 1955 (61);
Sheffield, Mappin Art Gallery. *British Painting 1900–1960*, Dec.
1975–Jan. 1976 (96); Graves AG; *Headhunters: an exhibition of
fantastic faces*, Arts Council touring exhibition (Eastbourne,
Durham, Oldham, Stoke-on-Trent, Graves AG, Sheffield,
July 1984–Jan. 1985 (49, as *Mrs[sic] Cicely Hamilton*)
REPR: *Burlington Magazine* 123, Feb. 1981, p.126
Sheffield City Art Galleries

This is the first portrait by Lowinsky that has survived. As an
example of this genre, it stands alone at this period of
Lowinsky's career, in that he turned almost exclusively to
portraiture only in 1932. In it he has abandoned the dramatic, if
tradition-bound use of the profile (see figs.10 and 11) while still
choosing to show only head and shoulders (his later portraits
tend to be three-quarter length ones). It is unusual too, for
depicting a family friend, since in later years Lowinsky was to
paint only hired models. Cicely Mary Hamilton (1872–1952) was
a prolific writer of plays, as well as an actress, travel journalist
and lecturer, chiefly on feminist topics. Co-founder in 1908 of
the Writers' Suffrage League, her best-known book is the
polemical text *Marriage as a Trade* (1909). That she was a friend of
the Lowinsky family is somewhat surprising, in that neither
husband nor wife were in the least bit interested in, let alone
committed to the Feminist movement. This notwithstanding,
the portrait is an immensely sympathetic one, full of the
understated but penetrating insights, both physical and
psychological, characteristic of all his work in this genre. Cicely
Hamilton appears here as a woman of fine and incisive
intelligence, and of considerable dignity. The painting was
presented to Sheffield in 1936 by Chas. Wilfred Janson, who had
purchased it from the Leicester Galleries in 1926.

15 Hagar in the Wilderness 1926
Oil on canvas 27½ × 28 (69.2 × 71)
Inscribed: 'TEL [in monogram] 1926' b.l.
EXH: Carnegie Inst., 1937 (134); Wildenstein (10); Graves AG
Justin Lowinsky

This painting takes its inspiration from the story in the Old
Testament Book of Genesis which tells of the banishment of
Hagar and Ishmael. Ishmael was the patriarch Abraham's first
son, born of Hagar, Egyptian handmaiden to Abraham's wife
Sarah. When Isaac, Sarah's son was born, Ishmael's mockery of
his younger brother provoked Sarah to demand that Abraham
banish both Ishmael and his mother; whereupon Abraham
provided them with bread and water and sent them out into
the desert of Beersheba. Divine intervention saved their lives,
however: for when their supplies ran out and Hagar, having
abandoned her baby under a bush, was on the point of despair,
an angel appeared and disclosed the presence of a nearby well.
Two scenes feature in art, the banishment and the appearance
of the angel, both of them common in seventeenth century
Dutch and Italian painting. Typically, Lowinsky has chosen to
depict the former (or rather, its aftermath), a bleak scene of
loneliness and desolation, in which, however, Hagar, cradling
her child, retains her dignity as a noble figure worthy of a place
in Greek tragedy. The extraordinary rock formations that
surround her on all sides, suggestive of prehistoric monoliths
or elemental architecture, redolent of human history, seem
strangely protective. Their theatrical forms cannot fail to bring
to mind the stage sets of Edward Gordon Craig, with which
Lowinsky would undoubtedly have been familiar. Colours are
muted and limited in range, consisting primarily of pale blue
for the sky, pinkish-greys for the rocks and creamy-tan for the
ground; Hagar and her baby, in bleached green, yellow and
terracotta robes, provide a slightly stronger accent. The scene
as Lowinsky portrays it is an intense and dramatic one, for all
that virtually nothing is actually happening.

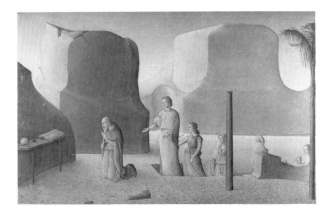

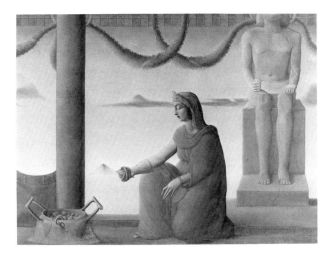

16 The Temptation of St Antony 1927
Oil on canvas $23\frac{3}{4} \times 38\frac{1}{4}$ (60.3×97.1)
Inscribed: 'TEL [in monogram] 1927' b.r.
EXH: Carnegie Inst., 1934 (130, repr. in b/w, pl.73, as 'The
Temptation of St Anthony'); Wildenstein (12); Graves AG
T.G.L. Thirkell Esq.

St Antony (otherwise known as Antony the Great or Antony,
Abbot) was a Christian saint and hermit, born in Upper Egypt
in the third century AD, and generally regarded as the founder
of monasticism since, on the death of his parents, he distributed
his property to the poor and retired into the desert, where he
lived in solitude for many years. Like other hermits, Antony's
solitary and ascetic existence made him subject to vivid
hallucinations. In art, these 'temptations' take two forms:
firstly, violent assault by demons and monsters who tear his
flesh and even carry him aloft; and secondly, lustful and erotic
visions of female flesh parading itself before him. Predictably, it
is the latter that has proved the more popular subject.
Although it is the one that Lowinsky, too, has chosen, it is
treated here in a surprisingly, almost disconcertingly asexual
manner. Against a backdrop of dramatic rock forms reminisc-
ent of those in 'Hagar in the Wilderness' (cat.no.15), Antony is
shown deep in steadfast prayer, facing resolutely towards his
makeshift altar, away from the procession of women seeking to
divert him. Four of the female figures are clothed; the body of
the fourth is hidden by a fragment of rock, her head
mysteriously swathed so that she becomes almost sphinx-like.
The two bringing up the rear are shown naked, but, like the
others, remain seemingly immobile and curiously chaste. As in
nearly all Lowinsky's mature oeuvre, the strikingly bold overall
forms of the composition are countered by miniscule details: a
tiny palm tree on the far shore, half way down on the right, a
flock of birds in flight just to the right of the strangely
columnar tree stump; and strewn on the ground, the
fragments of rock, sharp and slightly sinister, that appear in all
Lowinsky's imaginative compositions from the early 1920s
onwards. Colours, as ever, are pale and subtle: pinks, mauve
and lilac, pale blue and green predominate. The vestiges of a
grid at the edge of the canvas offer an interesting insight into
the artist's working methods.

17 Cleopatra 1928
Oil on canvas $21\frac{3}{4} \times 29\frac{1}{4}$ (55.3×74.3)
Inscribed: 'TEL [in monogram] 1928' t.r.
EXH: Wildenstein (13); Graves AG
Serena Thirkell, artist's granddaughter

Although Cleopatra (68–30 BC), Queen of Egypt, was a real life
figure, her beauty, intellect, extravagant hospitality and, above
all, her romance with Mark Antony has acquired mythic
proportions (aided, of course, by Shakespeare's famous
tragedy). When the joint military might of Antony and
Cleopatra was defeated by Octavian (Augustus) in a battle
which led to the latter's invasion of Egypt, Antony's forces were
again beaten and he committed suicide. Devastated by her
lover's death and refusing to accept defeat, Cleopatra took her
own life, supposedly by clasping a cobra, or asp, to her breast. In
Plutarch's account of events, which acted as inspiration for
many artists (particularly in seventeenth century Italy), a
number of her female attendants die with her. Lowinsky, as
always preferring to show a human being's essential loneliness,
portrays the queen alone, with only an enigmatic and sinisterly
truncated Egyptian sculpture for company (note also the
decoration on the column to the left, and on the awning
behind the lethal basket and elsewhere, all evocative of ancient
Egyptian art). Cleopatra, inscrutable and immobile, eyes tightly
closed, crouches tensely poised for action, the snake already
coiled around her extended right hand. Unusually, another
snake (or perhaps two) can be seen in the basket, presumably of
figs, in which the queen is traditionally supposed to have
concealed it. The tension of the scene is intensified by the
curious discrepancies in scale, notably between the foreground
figures and the tiny pyramid (echoed by the cloud formations),
and the ambiguity of the setting: where exactly is all this taking
place – inside or out? As ever, Lowinsky seems to be showing
the fragility of the structures we humans construct for
ourselves. Colours, in keeping with the nature of the scene
being depicted, are rather more brooding than in most of his
mature oeuvre.

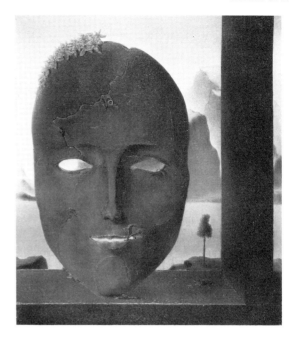

18 The Breeze at Morn 1930

Oil on canvas $17\frac{1}{4} \times 36$ (43.8×91.4)

Inscribed: 'TEL [in monogram] 1930' t.l.

EXH: Carnegie Inst., 1934 (132) and San Francisco Museum of Art, 1935 (120) (as 'Breeze at Morn'); Wildenstein (23, as 'The Morning Breeze'); London, Arts Council of Great Britain. *Landscape in Britain 1850–1950*, 1983 (170)

Tate Gallery

Unlike most of Lowinsky's imaginative compositions, this painting has no obvious or precise biblical, mythological or literary source, although the stylized head representing the morning breeze clearly derives in part from an admiration for the work of Burne-Jones, and through him, Botticelli. The dramatic, desert-like setting and the startling shifts in scale (note particularly the two tiny and elongated female figures carrying pots on their heads across the seemingly vast plain) have their precedents in works painted by Lowinsky in the 1920s, as to a more limited extent do the striking foreground forms; the botanical precision with which the plant forms are depicted, on the other hand, had lain dormant since the painting of 'Daphne' in 1921. Just because there is no traditional narrative underpinning this composition, it carries a greater potential for poetic reverie than most of Lowinsky's work, and as such, has distinct affinities with the tightly painted, surreal landscape images of artists such as John Armstrong and Ithell Colquhoun – these, however, were produced rather later in the decade, and directly under the influence of European Surrealism. The Contemporary Art Society, which bought the painting from the artist in 1940 for £80, presented it to the Tate Gallery in 1941.

19 The Mask of Flora 1931

Oil on canvas $12\frac{1}{4} \times 10\frac{7}{8}$ (31.1×27.7)

Inscribed: 'Thomas Lowinsky pinxit' b.r.; 'The Mask of Flora' b.c.

EXH: Wildenstein (24); London, Arts Council of Great Britain. *Thirties: British Art and Design before the War*, 1979–80 (5.35, as 'The Masque of Flora')

Wolverhampton Art Gallery and Museums

This is by far the most overtly surreal and disturbing of Lowinsky's paintings. Far from depicting Flora, the ancient Roman goddess of flowers, as a comely young maiden, as was common practice in old master painting (consider, for example, Botticelli's 'Primavera'), Lowinsky exposes the related ideas of flowers, springtime, youth and beauty as nothing but a sham or veneer; worse still, however, the mask, precariously perched on some kind of sill, only partially conceals the emptiness beyond. The organic forms that emerge from the orifices of the mask, uncomfortably reminiscent of writhing worms, speak primarily of decay. The colours in the painting are sinister too: predominantly purples, blues and greys, with a few touches of russet. Although the composition is among the smallest of Lowinsky's oil paintings, it has a starkly monumental power that makes it one of his most distinctive and memorable works. Why Lowinsky should have painted such a bleakly pessimistic work in 1931 is, however, unclear. Sir Kenneth Clark, who originally bought the painting and presented it in 1946 to Wolverhampton via the Contemporary Art Society, was a friend of Lowinsky, who appears to have offered Clark considerable support in the early part of his career.

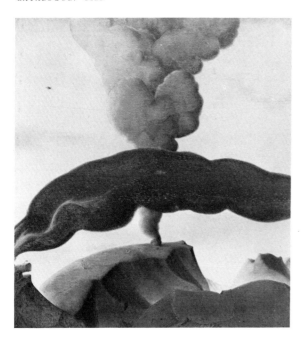

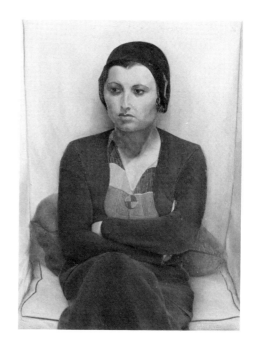

20 The Offering of Cain and Abel 1932

Oil on canvas $20\frac{5}{8} \times 19\frac{1}{4}$ (52.4×48.9)

Inscribed: 'Thomas Lowinsky pinxit' b.r.; monogram and date?; title b.r.

EXH: NEAC, 1933 (176); Warsaw. *Contemporary British Art*, 1939 (57); Kettering Art Gallery, August 1947; Stalybridge, Astley Cheetham Public Library and Art Gallery. *15th Annual Exhibition of Contemporary Art*, 1951 (21)

Sheffield City Art Galleries

The Book of Genesis describes how the first children of Adam and Eve, Cain, a settled farmer and Abel, a nomadic shepherd both presented their offerings to God – Cain, a sheaf of corn, representing his harvested crops; Abel, a sacrificial lamb, the best of his flock. When God refuses Cain's offering and accepts that of Abel, Cain kills his brother out of anger and jealousy. Branded by God with 'the mark of Cain', the first murderer, he was condemned to the life of a fugitive and vagabond and was later slain accidentally by a hunter who mistook him for a wild beast. The actual killing of Abel has far greater currency in art than the scene of the offering, which is found mainly in Northern European images of the twelfth and thirteenth centuries. The story was easily given a typological significance, whereby Abel the shepherd became a forerunner of Christ, with Cain foreshadowing the treachery of Judas. In Lowinsky's painting, however, it is difficult to say with any certainty exactly what is going on (although it does appear that he has conflated the two scenes into a single image): what is clear is that human action is utterly overwhelmed and rendered insignificant by the elemental power of the Divinity, as embodied in the craggy, empty mountainscape and the two vast plumes, one presumably of smoke, the other of cloud (and note, too, the tiny arm extended at the lower left edge of the composition). Blue, conventionally the colour associated with

a heavenly or spiritual realm, predominates. The painting was bought by Sir John Rothenstein for the Sheffield City Art Galleries in 1936 while he was their first director.

21 Miss Serinka Negrearnu 1932

Oil on canvas $27\frac{3}{4} \times 21$ (70.5×53.3)

Inscribed: 'A Portrait of Serinca Negriano [sic?] by Thomas Lowinsky 1932' (in capitals) b.r.; 'TEL [in monogram] 1932' t.r.

EXH: NEAC, 1932 (141, as 'Serinka'); Wildenstein (15, as 'Miss Serinka Negreaun' [sic]); Graves AG

REPR: *Times Literary Supplement*, 16 Jan. 1981, p.56

Private Collection

This fine painting marks the beginning of Lowinsky's rejection of biblical and mythological subject-matter in favour of the more earthbound genre of portraiture which was to occupy him almost exclusively in the latter part of his career. The reasons for this change are difficult to establish, although it may be that – consciously or not – Lowinsky had suffered too long from a sense that his imaginative work was far too unfashionable to succeed in conventional terms, and felt that turning to portraiture might lead to greater recognition. Like all his subsequent work in this genre, the sitter is a hired model (presumably, judging from the name, Rumanian – the discrepancies in spelling are due both to the artist's dyslexia and the name's unfamiliarity), a lady of indeterminate age and of no particular distinction. Unusually, though, she is depicted in a frontal position (although as in the later works, her legs have been omitted); and she has distinctly more sensuous appeal than do the later models. Black-haired, she wears a purplish-brown suit, orange, beige and brown patterned blouse and reddish-brown hat; while the armchair in which she sits with

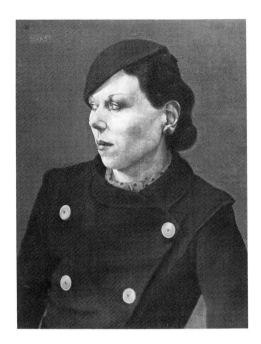

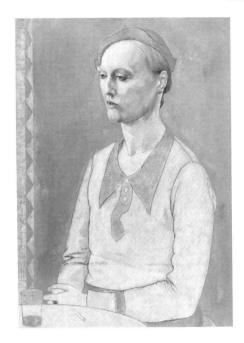

easy poise is buff-coloured, its cushion mustard and grey-blue. The rich orange of her lips picks up the orange of her blouse with great effect. In raking light it is possible to make out the preliminary outlines of the composition.

22 **Miss Jean Brady** 1933

Oil on canvas 17¼ × 13¼ (43.8 × 33.7)
Inscribed: 'Thomas Lowinsky, 1933', halfway down on right
EXH: NEAC, 1935 (107); Newcastle-upon-Tyne, Laing Art Gallery. *Some Phases of British 20th Century Art*, 1948 (4) (touring exhibition organized by Federation of Northern Museums and Art Galleries); Wildenstein (11); Carlisle, Carlisle Museum and Art Gallery. *The Purchase Scheme 1933–1975*, 1975 (18)
LIT: Gwynne-Jones pp.37–8
Carlisle Museums and Art Gallery

This sitter, like all Lowinsky's subsequent models, is quite lacking in the glamour, fame or notoriety expected of most female portrait subjects in the modern period. More even than the others, Miss Brady's clothes and demeanour speak clearly of a genteel, lower middle-class background. Lowinsky paints her with considerable sympathy, however, so that her rather sharp, pert features and 'sensible' clothes come to express strength of character and a quiet dignity. The colours he uses are muted; there are no extraneous details to distract the viewer from the solid dependability of the woman's body, jauntily and confidently positioned so that the angle of her beret neatly echoes that of her torso. This painting was bought by Sir William Rothenstein, a great admirer of Lowinsky's work (see also pp.19–20) in 1939, when he was employed as the first Honorary Advisor to Carlisle City Art Gallery.

23 **Miss Eileen Hawthorne** (unfinished) 1934

Oil on canvas 27½ × 20 (69.8 × 50.8)
Inscribed (in capitals): 'T. Lowinsky 1934' b.l.; 'Unfinished portrait of Miss Eileen Hawthorne by Thomas Lowinsky' on back of frame
EXH: Wildenstein (18, as 'Portrait of Miss Eileen Hawthorn')
Amcotts Wilson

Miss Hawthorne (about whom, as is the case with all Lowinsky's models, with the notable exception of Cicely Hamilton, see cat.no.14, we know absolutely nothing save what comes across in the painting) is presented here as a plain, but sympathetic woman with an introverted, serene and slightly enigmatic expression. That expression, combined with the overall spareness and angularity of the composition may well remind the viewer of some of the images of women Picasso painted during his 'blue period'. Her hair is the colour of pale corn, her eyes are grey, her lips red, and she wears a grey-green earring and a blue-grey hat. Her blouse is a pale tan, its collar and cuffs a darker shade of tan to match her skirt. The backdrop is greenish-grey; the unfinished areas of the composition (Lowinsky was clearly concentrating on the head first, and working from top to bottom) reveal a scumbled layer of underpaint ranging from cream to beige. Being unfinished, it is easy to see the firm pencil outlines that comprised Lowinsky's only concession to preliminaries. The reason for the portrait being left incomplete remains a mystery.

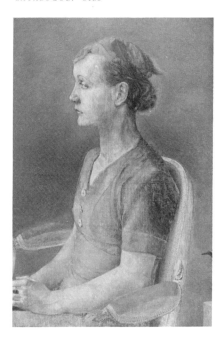

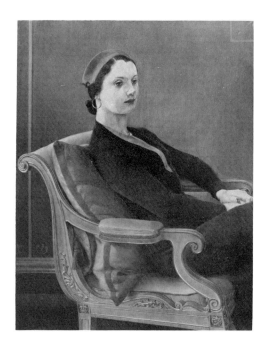

24 **Miss Ivy Beasley** 1934
Oil on canvas 19¾ × 13 (50.1 × 33)
Inscribed (in capitals): 'Thomas Lowinsky 1934' b.l.
EXH: ?NEAC, 1934 (as 'Portrait of a Young Woman');
Wildenstein (18)
Xenia Field

Once again, Lowinsky has chosen to place his model at a
curious and somewhat unexpected angle (one that, in this case,
harks back to the full profile treatment of his earliest portraits –
see figs.10 and 11). Like all his sitters in the 1930s, Miss Beasley
does not confront us directly; her eyes are averted, her privacy and
integrity respected. Wearing a dress of pale green and a
greenish-blue hat (whose leafy decoration links up with the
plant and the motif on the chair, and compares interestingly
with cat.no.46), she sits erect and still, in a lilac and green
armchair against a terracotta background. This time Lowinsky
pays rather more attention to the decorative details of the
armchair than in 'Miss Serinka Negrearnu' (cat.no.21) and re-
introduces the intriguing and compositionally-effective device
of the tip of a house-plant that he used in the portraits already
mentioned. The photograph of this painting in the early stages

of its production reveals Lowinsky's careful delineation of
contour as a necessary preliminary stage; and as with his other
portraits, an initial concentration on the face.

25 **Mrs James Mackie** 1935
Oil on canvas 22½ × 17½ (57 × 44.5)
Inscribed 'TEL [in monogram] 1935', b.r. and 'T. Lowinsky',
b.l. on chair
EXH: RA. 1940 (56, as 'Mrs James McKie'); included in list of
Wildenstein exhibits (as no.26), but in fact shown in
exhibition of Chantrey collection, RA, Jan.–March 1949
(238); RA. *Some Chantrey Favourites*, 1981 (17 as 'Mrs James
Mackie'), b/w ill.; London, Tate Gallery (in association with
Sheffield City Art Galleries). *Within These Shores, A Selection of
Works from the Chantrey Bequest 1883–1985*, 1989 (23, repr. in b/w
p.64, in colour p.38 (as 'Mrs James McKie'))
Tate Gallery

The greater opulence and ornateness of the armchair in which
Mrs Mackie sits (cf. cat.nos.21 and 24) appears to reflect – and
reinforce – the more moneyed, relaxed and debonair manner
of the sitter. As with all his portraits of these years, however,
everything is understated; although a small smile plays about
her lips, Mrs Mackie's thoughts remain impossible to fathom.
Colours remain low-key, with the single bright red fingernail
picking up the red of her lips and providing an unexpectedly
sensuous note. As always, Lowinsky's sense of an harmonious
and balanced composition triumphs, as vertical, horizontal and
diagonal lines echo each other across the picture surface. This
painting was purchased from the artist in 1939 for £125 under the
terms of the Chantrey Bequest, an arrangement dating back to
the nineteenth century whereby a certain amount of money
was made available each year for the purchase of works by
British painters and sculptors.

Miss Ivy Beasley 1934, photograph
taken when work in progress

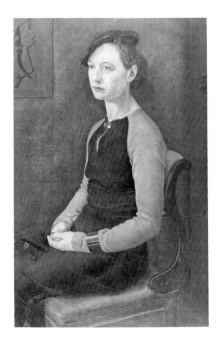

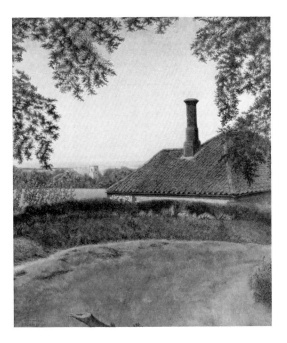

26 Miss Despard c.1935
Oil on canvas 22¼ × 14½ (56.5 × 36.8)
Inscribed (in capitals): 'T. Lowinsky' l.r.
EXH: Wildenstein (20); Graves AG
Katherine Thirkell née Lowinsky

Colour and form combine in this fine portrait to convey an impression of gentle dignity and acceptance of one's lot. The colours, forming a quiet harmony, almost a symphony, of greens, deep blue-greens and charcoal grey, are even more subtle and close-keyed than usual. The generous curve of the back of the armchair seems only to emphasize the meagreness of the middle-aged woman's body, until we note how the former is in fact echoed by the curve of the sitter's buttocks against the chair seat. The inclusion of the Japanese decorative elements in the background recalls J.M. Whistler's use of similar motifs, and his insistence on the analogies between colour and music. As is so often the case with Lowinsky's work, it is the overall harmony of the composition that strikes the viewer first; significant details reveal themselves only on closer scrutiny. Here it is the eye decoration on the side of the armchair that provides the visual surprise: wide-open and unchanging, it stands in ironic contrast to the veiled introversion of Miss Despard's gaze.

27 Brancaster from the Hill 1936–8
Oil on canvas 16 × 13½ (40.5 × 34.3)
Inscribed (in capitals): 'T. Lowinsky 1936–1938' b.l.
EXH: Wildenstein (22)
Clare Stanley-Clarke née Lowinsky

Landscape painting was never a major preoccupation with Lowinsky. Only two examples, both unlocated, preceded this one: 'Brightling Ridge through Rain' of 1922, an amorphous, if atmospheric, almost Turner-esque composition and the image of a cottage and a country lane painted in 1924 (fig.12), not dissimilar in composition from the Brancaster painting, although rather more freely executed. It does, however, seem to have provided him with relief both from his work in other genres and from the demands of family life, as most of his landscape images appear to have been painted while on summer holidays in the English countryside, where it was the family's practice to rent a house (often for several summers in succession). In the early 1930s, for example, the Lowinskys had spent the summers in Stanway in Gloucestershire; while from 1936 onwards they transferred their allegiances to the village of Brancaster in Norfolk, where they rented several different properties. Although not a particularly striking composition, 'Brancaster from the Hill' reveals Lowinsky's ability (evident also in the portraits) to find significance in the unglamorous and ordinary. Here, every humble feature of the scene is treated with the same meticulous attention to detail; although human beings do not feature directly in this work, their ordering presence is everywhere implicit.

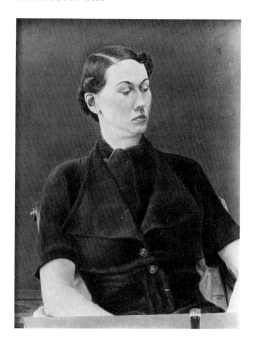

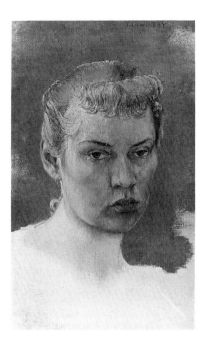

28 Miss Avril Turner 1937
Oil on canvas 17¾ × 13⅜ (45 × 34)
Inscribed (in capitals): 'T. Lowinsky 1937' l.r.
EXH: Wildenstein (3, as 'Miss Averil Turner')
LIT: Gwynne Jones p.37, repr.
Visitors of the Ashmolean Museum

Miss Turner comes across in this painting as a rather 'prickly' character, her body tensed, and her features drawn inwards to convey an attitude of slight self-righteousness and distinct disapproval – of the artist, of having her likeness recorded, quite possibly of life in general. Even the diminutive size of the glass on the table in front of her, whether Lowinsky himself intended it or not, suggests a certain meanness of spirit, while the angularity of the composition as a whole (note, for example, the sharp corners of the dress lapels, echoed by the position of her arms, and her right elbow in particular) confirms and reinforces one's first impression of the sitter. The painting was presented to the Ashmolean Museum by Mrs Lowinsky in 1948, probably because of Lowinsky's longstanding friendship with Sir Karl Parker, Keeper of its Department of Fine Art for many years.

29 Unfinished Head of a Woman c.1938/9
Oil on canvas 9¼ × 5¾ (23.5 × 14.6)
Inscribed (in capitals): 'T. Lowinsky' top, right of centre
EXH: Wildenstein (24, as 'Unfinished Portrait'); Graves AG
Katherine Thirkell née Lowinsky

According to the artist's eldest daughter, this was originally part of a larger composition (probably, judging from his other works in this genre, a three-quarter-length portrait), which for some reason was then cut down to its present size. In any event, it was left unfinished at the outbreak of the Second World War, which seems to have robbed Lowinsky of the will to paint. As with cat.no.23, he has started work at the top of the composition, devoting most of his attention to the woman's head and delineating his forms with pencil first. The sitter, her corn coloured hair in close harmony with the deep tan background, has not been identified.

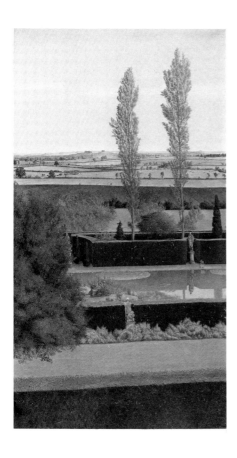

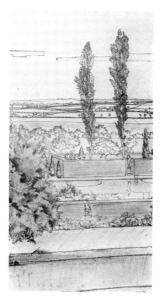

Garsington 1939–45, photograph
taken when work in progress

30 Garsington 1939–45

Oil on canvas $36\frac{1}{2} \times 19\frac{1}{2}$ (92.7×49.5)

Inscribed 'In Memory of Martin who loved Garsington' l.r.

EXH: Leicester Galls., 1947 (mixed exhibition); Wildenstein
(1); Graves AG

LIT: *New Statesman and Nation*, 2 Aug. 1947 (review of Leicester
Galls. exhibition); Gwynne-Jones p.38

Justin Lowinsky

The Lowinsky family moved to Garsington Manor in Ox-
fordshire shortly after the outbreak of the Second World War.
Around the time of the First World War the house had gained
fame, not to say notoriety, as the home of Bloomsbury art
patroness, Lady Ottoline Morell. (Mark Gertler painted the
house and gardens several times at this period.) Garsington
remained the Lowinskys' full-time home throughout the war.
This painting's curious perspective, extremely subtle deploy-
ment of colour and almost obsessive attention to detail (see
also illustration showing the painting in its unfinished state)
endows it with an almost super-realist intensity; while its
dedication to the son who lost his life in battle at the age of
twenty-one, combined with the fact that this was Lowinsky's
last painting, lends the work an extra poignancy. Allan
Gwynne-Jones described 'Garsington' as '... a large landscape
... It is, I think, his best work, and makes one realize even more
fully the loss English painting has sustained'. When the
painting was exhibited in a group show at the Leicester Galleries
in 1947, a few months after the artist's death, it received lavish
praise in the *New Statesman and Nation*: 'Then, in his last picture,

the "Garsington" now on view, he arrived at what strikes me as
an extraordinary achievement. It is a largish landscape, painted
in prodigious detail, as if by a miniaturist. No detail, however,
obtrudes, and the picture remains in tone throughout. Thus it
attains what I should have thought was an impossible aim, and
by way of more than photographic fidelity to appearances
arrives at a work of art. I have never before seen anything like it,
and probably never shall, for such a technique will hardly
excite imitation, entailing as it does a labour that seems
disproportionate to the advantages it brings. As a successful
and indeed unique experiment, this landscape deserves most
careful attention from everyone interested in the means of
pictorial expression, and deserves an honoured place in one of
our museums'. Sir John Rothenstein had in fact, it seems,
virtually promised to buy the painting for the Tate Gallery; his
failure to do so may well have contributed to, or been the result
of the two men's estrangement (see p.39).

Works on Paper

Where two dimensions are given, the first refers to the size of the image, the second to that of the paper.

31 Annunciation *c.*1912–14(?)
Lithograph (black ink) 5 × 4¼ (12.7 × 10.8); 10¾ × 8½ (27.3 × 21.6)
Inscribed: 'T.E. Lowinsky' b.r.
Justin Lowinsky

This is probably a student work, done while Lowinsky was attending the Slade. It naturally invites comparison with the far more elaborate and ambitious oil painting on the same subject which Lowinsky executed in 1920 (cat.no.6).

32 Pandora 1917
Lithograph (sepia) 8 × 5½ (20.3 × 14); 12 × 8¾ (30.5 × 22.3)
Inscribed: '1917' b.r.; 'T.E. Lowinsky' b.r.; 'Pandora' b.l.
Justin Lowinsky

This print (together with cat.nos.33 and 34), was presumably produced by Lowinsky in response to Ricketts's wartime advice (see p.14). The choice of Pandora, the figure from Greek mythology who, by opening a box forbidden to her, supposedly released evil on mankind, would have been in keeping with Ricketts's own subject preferences.

34

33 Mr Auguste Rodin 1917
Lithograph (green ink) $6\frac{3}{4} \times 6\frac{3}{4}$ (17.1 × 17.1); 11 × $8\frac{3}{4}$ (27.9 × 22.3)
Inscribed: '1917' b.l.; 'T.E. Lowinsky' b.r.; 'Mr Auguste
Rodin' b.l.
Justin Lowinsky

1917, the year in which this work was executed, was also the year
in which the famous sculptor Auguste Rodin died at the age of
seventy-seven. Ricketts's diary entry for 4 December 1917 (Lewis,
C. *Self-Portrait*, pp.284–5), although ambivalent in its attitude to
Rodin's oeuvre as a whole, acknowledges the debt his own
work owed to the sculptor: as Ricketts's protégé, Lowinsky
would also have considered Rodin's death a fitting occasion for
a tribute to him.

34 At the Crow of the Cock 1917
Lithograph (black ink) $4\frac{1}{2} \times 4\frac{3}{8}$ (11.4 × 11.1); $9\frac{1}{4} \times 6\frac{1}{4}$ (23.5 × 15.9)
Inscribed: 'T.E. Lowinsky' b.r.; '1917' t.r.; 'At the Crow of the
Cock' b.l.
Justin Lowinsky

Although this image clearly alludes to Peter's denial of Christ,
the facial type portrayed is close to that of cat.no.33.

35 Nerissa 1918
Sepia $4\frac{1}{4} \times 4\frac{1}{4}$ (10.8 × 10.8)
Inscribed: 'T.E. Lowinsky 1918' t.r.; 'Merchant of Venice:–
Design for Nerissa:– sand-coloured dress with red designs'
t.l.
Artist's granddaughter

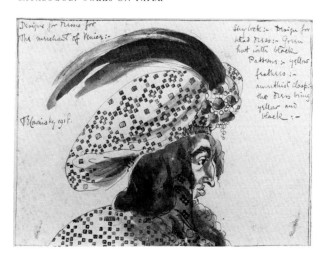

36 Shylock 1918

Sepia $4\frac{1}{2} \times 6$ (11.4 × 15.3)

Inscribed: 'T.E. Lowinsky 1918' halfway down on left;
'Designs for dresses for The Merchant of Venice:–' t.l.;
'Shylock:– Design for head dress:– green hat with black
patterns:– yellow feathers;– amerthist [sic] clasp:– the dress
being yellow and black' t.r.

Artist's granddaughter

38 Portia 1918

Sepia $8 \times 4\frac{1}{2}$ (20.3 × 11.4)

Inscribed: 'The Merchant of Venice:– Design for Portia:–
Dress and cap of white with black and green patterns:–
scalf [sic] and under-bodice of dark blue:– coral beads:–',
below image; 'T.E. Lowinsky 1918' b.r.

Artist's granddaughter

Cat.nos.35–38 are clearly costume designs for a projected
production of Shakespeare's famous play, which seems to have
held a special attraction for Lowinsky (see also his illustrations
to the 1923 edition of the play, cat.nos.43–44 and 47). Details of
this production, however, have proved unavailable; so it is not
certain whether the play was actually performed. (It is just
possible that Lowinsky was working in collaboration with
Charles Ricketts on a production of the play for the YMCA Hut
performances at Le Havre and Paris in 1918 (see Cecil Lewis: *Self-
Portrait*, pp.302–3).)

37 Jessica 1918

Sepia $3\frac{3}{4} \times 3\frac{1}{2}$ (9.5 × 8.9)

Inscribed: 'Jessica:– design for head-dress' t.l.; 'T.E.
Lowinsky 1918' t.r.; 'The Merchant of Venice:–' b.l.

Artist's granddaughter

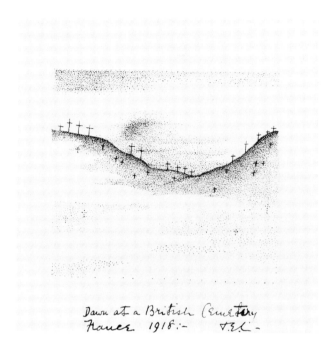

Dawn at a British Cemetery France 1918:– TEL–

39 Dawn at a British Cemetery, France, 1918 1918
Pen and ink $2 \times 2\frac{1}{4}$ (5.1 × 5.7); $3\frac{1}{4} \times 3\frac{3}{4}$ (8.3 × 9.5)
Inscribed with title and monogram below image
Justin Lowinsky

The correspondence between Ricketts and the young Lowinsky contains a reference (in a letter of August 1918) by the former to Lowinsky's earlier description of a 'desert of crosses' formed by a military cemetery: 'My dear Bengy, I can quite believe the desert of crosses was impressive … Why not write on the crosses under the evening sky or at dawn? . . .' (Lewis, C.: *Self-Portrait*, p.300). If Lowinsky did write a poem on the subject, it has disappeared without trace; in any event, it is possible that this experience inspired the tiny and very moving drawing illustrated here.

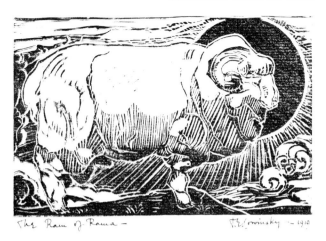

The Ram of Rama – T.E. Lowinsky – 1910

40 The Ram of Rama 1919
Woodcut $3\frac{3}{4} \times 6$ (9.5 × 15.3); $4\frac{3}{4} \times 6$ (12 × 15.3)
Inscribed: 'T.E. Lowinsky 1919' b.r.; 'The Ram of Rama' b.l.
Justin Lowinsky

This is an early example of Lowinsky's tendency to choose unusual, even, as in this case, obscure subject-matter. Rama is the main protagonist of the great Hindu epic, the *Ramayana*.

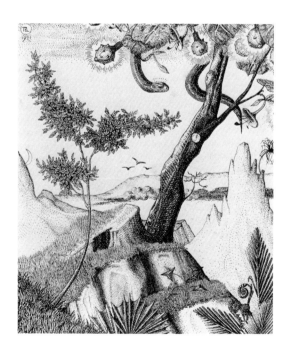

41 Fantastic Landscape 1921
Pen and ink $6\frac{1}{2} \times 5\frac{1}{4}$ (16.5 × 13.4)
Inscribed: 'TEL [in monogram] 1921' t.l.
Clare Stanley-Clarke née Lowinsky

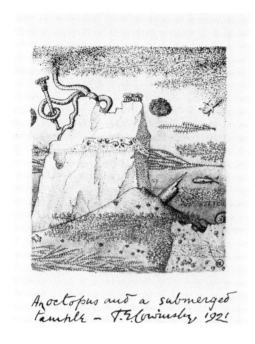

42 An Octopus and a Submerged Temple 1921
Black ink and blue wash 2¼ × 2 (5.7 × 5.1); 3⅞ × 4½ (9.7 × 11.4)
Inscribed with monogram and date b.r.; titled, signed and
dated below image
Justin Lowinsky

Cat.nos.41 and 42 reveal the fertility and originality of
Lowinsky's imagination at this early period in his career, as well
as his masterly command of linear detail.

43 Portia, Gratiano, Duke of Venice, Shylock 1922
Pen and watercolour 10 × 12 (25.4 × 30.5)
Inscribed: 'TEL [in monogram] 1922' b.r.
EXH: Graves AG
Justin Lowinsky

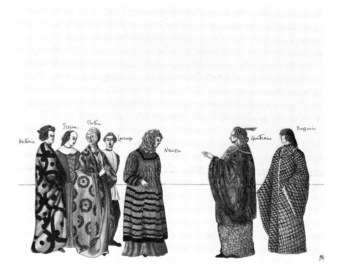

**44 Antonio, Jessica, Portia, Lorenzo, Nerissa, Gratiano
and Bassano** – *The Merchant of Venice*, Act V 1922
Pen and watercolour 10½ × 8⁷⁄₁₆ (26.8 × 21.4)
Inscribed: 'TEL [in monogram] 1922'
Trustees of the Victoria and Albert Museum

Cat.nos.43 and 44 form part of the series of original water-
colours Lowinsky executed for a 1923 edition of the Merchant of
Venice, the artist's first venture into the realm of book
illustration (see also cat.no.47).

45 Menu decoration for 28th Double Crown Dinner, Jan.
29th 1931 1930
Coloured wood engraving $7\frac{1}{8} \times 4\frac{3}{4}$ (18 × 12.1); $9 \times 6\frac{3}{4}$ (22.9 × 17.1)
Inscribed: 'TEL [in monogram] 1930' b.c.
Justin Lowinsky

The Double Crown Club is a dining club – with a difference.
Founded in 1924 by Oliver Simon with the express purpose of
providing a relaxed forum where 'people interested in the Arts
of the Book could meet together' (Simon, O. *Printer and
Playground*, p.34), its membership, deliberately kept small,
included Lowinsky, Paul Nash, Albert Rutherston, Francis
Meynell and Bernard Newdigate of the Shakespeare Head Press;
while the list of honorary members included Ricketts and
Shannon. At the gatherings of this 'Typographical Dining
Club', as it is called, members or guests present papers on
relevant matters for discussion and debate; in addition, a
member of the club is invited to produce a menu design for
each dinner, which is then subjected to heated critical analysis.
This is clearly the context for which this image by Lowinsky, a
founder member, was produced. (That he was made a member
only a year or so after he had embarked on book illustration is
surely an indication of his colleagues' respect.)

46 Dante's Mask 1932
Woodcut (edition of 200) $5\frac{1}{4} \times 4\frac{3}{8}$ (13.3 × 11.1); $7\frac{5}{8} \times 6\frac{3}{8}$ (19.3 × 16.2)
Inscribed: 'TL [in monogram] 1932' b.r.
Justin Lowinsky

It is tempting to view this curious image, with its civilized and
respectable veneer only barely controlling a penchant for the
bizarre, as a kind of metaphor for Lowinsky's own situation as
an artist and a gentleman – outwardly extremely 'proper',
inwardly teeming with strange visions. It is perhaps significant
that the print was executed in 1932, precisely at the time when
Lowinsky's imaginative faculties were to be subordinated to a
more earthbound approach.

For reasons already discussed (see p.18), Thomas Lowinsky has always been better known as an illustrator of books than as a painter. (His dyslexia, while making it difficult for him to read himself, did not prevent him from taking a great interest in literature. His wife, Ruth, it seems, would read aloud to him.) His ability to create images of considerable originality that nonetheless perfectly harmonize with the typeface and format of the literary work in question made him an exemplary figure in the twentieth century revival of the illustrated book. Sir Francis Meynell, co-founder of the Nonesuch Press (for which Lowinsky illustrated four books) rated his talent highly. 'As a book illustrator – but I think decorator is a better word for him –' he wrote in the catalogue introduction to the artist's 1949 memorial exhibition, 'Lowinsky had what one might call a proud subordination. He was completely convinced that "the book's the thing"; and he rejoiced in the discipline of making his line suit exactly the "colour" of the type with which it was to be associated, and of making his shapes suit the page. His pride, on the other hand, was shown in his insistence always that part at least of any edition must be printed on a particular hand-made paper, no other; and he could not be kept away from the machine-room when his pages were being proofed for impression and inking. Because of this integration with the text his book designs should be studied and will be admired in the books for which they were made.'

Twenty years earlier, an article on 'Modern English Book Illustration' by Douglas Percy Bliss (*Penrose's Annual*, vol.31, 1929) had ranked Lowinsky with E. McKnight Kauffer and Eric Gill as eminent exponents of 'the pursuit of technical harmony between the illustrations of the book and the types and ornaments that accompany them', all three 'typical of the new class of book illustrator in making their work for publishers only a small part of their artistic activity'. 'Thomas Lowinsky', wrote Bliss, '... has, by natural instinct or set intention, produced drawings of an even grey texture which perfectly take their place with type. They consist of pen lines kept apart or spread mesh-like over the surface to produce an effect like that of a diagram in an old embroidery book'. (The images were reproduced by making lineblocks from the original drawings; most remained black and white, although some – the illustrations for *Modern Nymphs*, for example – were coloured by hand.) 'But in spite of his formal style', Bliss continues, 'he does not lose character or expressiveness in his drawings. His work is pre-Raphaelite in its elaboration of detail, in its angular and somewhat grotesque types, and its bestowal of equal attention upon every inch of the surface'.

The characterization of Lowinsky's illustrative work contained in this last sentence does not, in fact, entirely do justice to his versatility and range as an illustrator, and is due largely to the fact that Bliss was writing in 1929. Thus, his emphasis on Lowinsky's penchant for the grotesque may hold true of the images he produced in the 1920s for *Paradise Regained, Dr Donne and Gargantua* or

Eric Gill **St Luke: Bookplate for Thomas Esmond and Ruth Lowinsky** 1922, wood engraving $4\frac{3}{8} \times 2\frac{1}{4}$ (11.2 × 5.8) *Justin Lowinsky*

Sidonia the Sorceress, but the inventively urbane wit and distinctly Art Deco quality of his later illustrations to his wife's cookery books, to *Modern Nymphs* and *Ladies' Mistakes* should not be overlooked. If we are to look for kindred spirits in the field of book illustration, it is figures like John Austen (1886–1948), Harry Clarke (1889–1931) and Alastair (alias Hans Henning von Voight) who come to mind, all three of them influenced to a large extent by the flamboyant decadence, linear elegance and mastery of black and white of Aubrey Beardsley's graphic work. Not coincidentally, perhaps, Alastair (1887–1969) illustrated Oscar Wilde's *The Sphinx* in 1920, a work for which Charles Ricketts had created the original illustrations in 1894. Like Lowinsky in *Ladies Mistakes* and *School for Scandal*, Alastair and Austen both on occasion produced supposedly 'period' images on an eighteenth century theme. Clarke's 'gothic' illustrations to Edgar Allan Poe's *Tales of Mystery and Imagination* (1919) have a certain affinity with Lowinsky's images for *Sidonia the Sorceress*, while his 1925 illustrations to Goethe's *Faust* possess an elegantly surreal quality not dissimilar to that found in much of Lowinsky's illustrative work. In the case of the cookery books, Edward Bawden's images for Ambrose Heath's cookery books of the 1930s, published by Faber & Faber, offer an obvious comparison. (Robert Harling has described Lowinsky's technique as an illustrator as 'balanced between Bawden and Cocteau'.)

Since most of Lowinsky's illustrations were produced for the so-called 'private' presses, a brief discussion of this phenomenon is in order. Although the term itself has no universally agreed on meaning, essentially it refers to small-scale publishing enterprises which put great emphasis on fine quality printing for a discerning and necessarily limited readership willing and able to pay that much extra for the gratification of handling aesthetically pleasing artefacts. Most accounts of the subject credit William Morris with first rescuing book production from the errors and excesses of the Victorian era through the founding of his Kelmscott Press in 1891 and its profound influence on subsequent presses, not least the Vale Press, founded by Charles Ricketts and Charles Shannon in 1896. (Lowinsky's close association with these two men in later years would have ensured his familiarity with their ideas and productions alike.) Other important presses dating from the 1890s include Eragny (founded by Lucien Pissarro), Essex House and Ashendene. Early twentieth century enterprises like the Shakespeare Head Press and the Fleuron, founded in 1904 and 1922 respectively (Lowinsky worked on a number of projects for both of these), the Doves, Gregynog and Golden Cockerel Presses (Eric Gill was closely associated with the latter), owe a considerable debt to their late nineteenth century precursors.

The highly successful Nonesuch Press, founded by Meynell and Stanley Morison in 1923, is something of an anomaly, in that from the start its founders were determined to avoid the exclusivity and suspicion of the machine characteristic of most of the presses mentioned above. Thus, although most of their illustrated books were produced in limited editions, they took advantage of new mechanical processes to keep their costs down and to encourage

technical experiments on the part of the artists they employed. In a sense, they were following the example of the Bodley Head firm of John Lane and Elkin Matthews (for which Ricketts produced illustrations, as he had done for the Kelmscott Press), also founded in the 1890s. As A.J.A. Symons put it (in *The Nonesuch Century*, p.30): 'It is in these books of the Nonesuch Press that the two rival conceptions of the 'Nineties, Morris's reforming desire for fresh types and finer materials, and the Lane-Matthews renaissance of the trade book, were first reconciled, and reconciled by the mastery of the machine'. Lowinsky's insistence that a certain number of copies of books illustrated by him be printed on hand-made paper would have led to financial problems, had not the artist been willing to pay for this luxury himself. Once again, it seems, the aesthete in him triumphed.

The following books are listed – as far as possible – in the sequence in which they were published.

47 Shakespeare, William. *The Merchant of Venice*
London: Ernest Benn Ltd, 1923. 13 × 9¾ (33.1 × 24.8); 104 pages; edition-de-luxe of 106 copies, price £12 12s; 450 copies price £4 4s
Justin Lowinsky

This volume formed the second in a series entitled 'The Player's Shakespeare', with introductions by the playwright Harley Granville-Barker, the general art editor being Albert Rutherston. Volume I was *Macbeth*, illustrated by Charles Ricketts. Since this was Lowinsky's first venture into the field of book illustration, it is reasonable to surmise from this constellation of acquaintances that once again it was Charles Ricketts who eased his entry into this area of artistic activity. *The Connoisseur* (June 1923, p.185) reviewed the first two volumes thus: 'Each volume is beautifully printed, and the bold and shapely type, admirably spaced and set, make it a delight to read. Yet the salient appeal of the edition is that it veritably forms what it professes to do – a *Players' Shakespeare*. The text followed is that of the "First Folio", unexpurgated and uncurtailed, all the original spellings being reproduced, together with the original stage directions. Mr Granville-Baker [sic] writes his Introductions from the point of view of the dramatic producer, and the illustrations of Mr Charles Ricketts and Mr Lowinsky are all in the nature of practical suggestions for the scene-painter and costumier. Perhaps the designs of the last-named artist are the most wholly utilitarian in this respect. His drawings, both in colour and black-and-white, for *The Merchant of Venice* are effective renderings of picturesque Renaissance costumes and scenic properties that could be adapted to any stage.' (It is presumably for this reason that his original drawings have on occasion been incorrectly identified as actual costume designs.) Five 'stage designs' for this play were included in Lowinsky's 1926 one-man exhibition, and a copy of the book featured in the 1949 memorial show. (See cat.nos.43 and 44 for original illustrations.)

Book I line 106 *He ended and his words impression left of much amusement to the infernal crew–*

48

48 Milton, John. *Paradise Regained*
London: The Fleuron, 1924. 9 × 7 (22.9 × 17.8); 82 pages; 350 numbered copies, price 15s
Justin Lowinsky

Lowinsky's illustrations to Milton's sequel to *Paradise Lost* on the theme of Christ's redemptive role (focusing exclusively on Christ's temptation in the wilderness, it was originally published in 1671) are elaborate and densely-worked, essentially faithful to the text but full of original and unexpected visual detail. One of the drawings was exhibited in 1926, and an illustration from the book (p.33) reproduced in F.J. Harvey Darton's *Modern Book Illustration in Great Britain and America*, 1931, p.127. This was Lowinsky's first project for The Fleuron, originally founded in 1922 by Oliver Simon and Stanley Morison for the purpose of publishing a typographical journal of the same name; it became a publishing house in 1925. As well as

49

being the driving force behind The Fleuron, Simon was also the founder of the Curwen Press, which printed most of The Fleuron's books and for whom Lowinsky designed two pattern papers (see cat.nos.60 and 61).

49 Meinhold, William. *Sidonia the Sorceress* (translated by Lady Wilde)
London: Ernest Benn Ltd, 1926. 12 × 9 (30.5 × 22.9); 486 pages; 225 copies
Justin Lowinsky

Meinhold's *Sidonia von Bork, die Klosterhexe*, originally published in 1847, is a blood-curdling 'gothic' romance (well-matched by Lowinsky's images), written in the form of a contemporary chronicle, which purports to trace the career of a girl from a noble Pomeranian family who, after a life of relentless crime, was burnt as a witch at Stettin in 1620. Lady Wilde's English translation appeared in 1849 and, as the advertisement for the book published in the catalogue of Lowinsky's 1926 exhibition tells us, 'exercised a most powerful fascination on many artists and poets, including Rossetti and Swinburne ...'. Burne-Jones's watercolour of 1860, *Sidonia and Clara von Bork* (in the Tate Gallery), of which – significantly – Ricketts sent Lowinsky a postcard reproduction in 1923, testifies to this fascination, as does William Morris's reprinting of *Sidonia* at the Kelmscott Press in 1893 and the appearance of a drawing by Reginald Savage, a member of Ricketts's circle in the 1890s, on the theme of *Sidonia and Otto von Bork on the Waterway to Stettin* in an article on Meinhold in *The Pageant* in 1896. Ricketts himself reissued Meinhold's other romance, *The Amber Witch* at the Vale Press in 1903. Lowinsky's illustrations can thus be seen as the culmination of a tradition, to which, in their stylistic references (to Rossetti, Burne-Jones and through them, to Dürer and

German sixteenth century engravings), they clearly pay homage. Seven of the original drawings were exhibited in 1926, together with one unpublished drawing, and a copy of the book was exhibited both in 1949 and in 1989, in *The Last Romantics* exhibition at the Barbican Art Gallery, London (cat.no.376, p.173). Douglas Percy Bliss (see above, p.56) singles this book out for special mention.

50 Khayyam, Omar. *Rubaiyat* (translated by Edward Fitzgerald)
Stratford-upon-Avon: Shakespeare Head Press; Oxford: Basil Blackwell, 1926. $7\frac{5}{8} \times 5\frac{3}{4}$ (19.4 × 14.7); 44 pages; soft cover price 2s 6d; hard cover price 4s 6d; 55 copies printed on handmade paper
Justin Lowinsky

This hedonistic celebration by a medieval Persian astronomer-poet of the life of the senses had been popular with British illustrators ever since the appearance of Fitzgerald's English translation in 1859. (A Bibliographical Note in this edition mentions the fact that Rossetti and Swinburne had 'discovered' the first edition with enthusiasm.) Edmund Dulac, a friend of Lowinsky, had, for example, illustrated the poem in 1909. Unlike the latter's colourful and intricate images, Lowinsky's illustrations, few in number, are spare and restrained, revealing an attempt on his part to capture a middle-eastern flavour by reference to the forms of Assyrian art. The year 1926, which saw the appearance of this and four other books illustrated by Lowinsky, seems to have been a particularly productive one for him.

Tailpiece to "Playing Cards"

Tailpiece to poem.

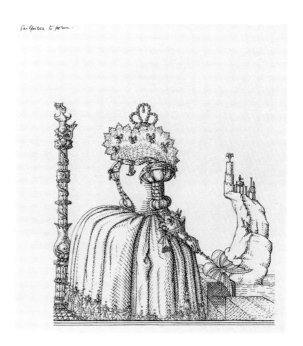

51 Sitwell, Sacheverell. *Exalt the Eglantine and Other Poems*

London: The Fleuron, 1926. $8\frac{3}{16} \times 6\frac{13}{16}$ (20.8 × 17.3); 48 pages; 370 copies (350 for sale, price 21s)

Justin Lowinsky

Sacheverell Sitwell's impressive series of poems was inspired by his coming across an Elizabethan table at Hardwick Hall in Derbyshire with the following lines inlaid in marquetry: *The redolent smle of aeglantyne/We stagges xavet to the Deveyne*, and is a lyrical, if sometimes melancholy homage to a lost world of chivalry. Lowinsky was closely acquainted with all three Sitwells (as were Albert Rutherston and Francis Meynell), and seems to have been a regular and long-standing guest at Renishaw Hall, their ancestral home in Derbyshire. Osbert Sitwell recalled that, especially during the years immediately following the First World War, 'there were relays of very young writers, musicians, poets, painters, whom my sister, my brother or I had asked'. The book's cover is decorated with one of Lowinsky's own designs. A copy of the book, with its nineteen illustrations, was exhibited at Wildenstein & Co. in 1949.

52 Sitwell, Sacheverell. *Dr Donne and Gargantua, Canto the Third*

Stratford-upon-Avon: Shakespeare Head Press, 1926. $10 \times 7\frac{5}{8}$ (25.2 × 19.4); 24 pages; 65 copies (50 for sale)

Katherine Thirkell née Lowinsky

The First Canto of this long epic poem was published in 1921, with an illustration by Wyndham Lewis; 'Canto the Second', appeared in 1923 with 'two decorations' by Gino Severini (both of these were issued by the Favil Press). Gargantua the giant was a fictional character created by the French writer Rabelais in the sixteenth century; John Donne was a poet of the 'metaphysical' school living in seventeenth century England. The theme of the poem is the conflict between good and evil, between the spiritual and the physical. Sacheverell's sister Edith described it as 'the battle against God from a universe that man has changed to a world of chance and doom – the attempt to conquer Fate by means of taming the elemental forces and the forces of nature into an unnatural servitude to man. The two worlds, the real and the metaphysical, of which Gargantua and Donne are the protagonists, have become brothers; they march side by side in their endless and hopeless battle, meeting interminably and unwittingly the Third Protagonist, who watches, waits, beneath a myriad disguises'. Lowinsky's frontispiece to this work was reproduced in *Apollo* 112: 160, Sept. 1980.

53 Sitwell, Edith. *Elegy on Dead Fashion*

London: Duckworth & Co., 1926. $9\frac{1}{2} \times 6\frac{1}{4}$ (24.3 × 16); 32 pages;
225 copies (200 for sale, price 12s 6d)
Katherine Thirkell née Lowinsky

This *Elegy on Dead Fashion*, with seven witty drawings by
Lowinsky, was a greatly revised and extended version of
Fashionable Intelligence, 1843, printed in *Poor Young People*, a collection
of poems by all three Sitwells, originally published in 1925 by
The Fleuron with illustrations by Albert Rutherston. Both the
poem, a somewhat melancholy series of reflections on the
passing of time, and the illustrations clothe female figures from
classical mythology in nineteenth century costume. A copy of
the *Elegy* . . . was included in Lowinsky's memorial exhibition in
1949. Clare, Lowinsky's youngest daughter, was Edith Sitwell's
goddaughter.

54 Voltaire, Francois Marie Arouet de. *The Princess of Babylon*

London: The Nonesuch Press, 1928. $7\frac{3}{8} \times 4\frac{1}{2}$ (18.8 × 11.4); 156
pages; 1,500 copies, price 15s
Justin Lowinsky

This was advertised in the 1927 Nonesuch Press *Prospectus and
retrospectus* as follows: '*The Princess of Babylon* is the airiest and most
charming of all Voltaire's romances. Never, one thinks, was he
more aware that he was writing for the fine ladies as well as for
philosophers, never are his wit and style more perfect. In the
words of Lytton Strachey: "His periods are pirouettes with all
the latent strength of a consummate dancer". It is the most
fanciful and poetic of his parables and yet it has the true
Voltairean tang of malice . . . Mr Lowinsky's drawings are true
decorations, composed very harmoniously with the classical
"grey" page. The artist – and the printer and paper-maker –
have not forgotten the author's objective. They too have
worked for the fine ladies and the philosophers'. A.J.A. Symons
(in *The Nonesuch Century*, p.21) described this, the first, as the most
successful of Lowinsky's four contributions to Nonesuch Press
publications. Certainly, as John Dreyfus has pointed out, the
illustrations are carefully designed to match the tall foolscap
format of the book: 'They have a very formal quality, most
skilfully rendered to accord with the type matter; but they are
deliberately kept low-key and cool' (*A History of the Nonesuch Press*,
p.150). The opening page was reproduced in Francis Meynell's
Some Collectors Read, 1931 (published in *The Colophon*, I, part iv, Dec.
1930 (NY); reprinted in Paul Bennett: *Books and Printing*, Cleveland,
1951).

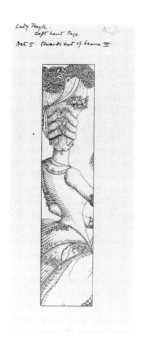

55 Mortimer, Raymond (introduction). *Modern Nymphs*
London: F. Etchells and H. Macdonald (Haslewood Books), 1930. $7\frac{1}{2} \times 12$ (19 × 30.5); 73 pages; 150 copies. Plates coloured by hand
Justin Lowinsky

Unlike most of the books illustrated by Lowinsky, in which the text occupied most of the space, this was essentially 'a series of 14 fashion plates by Thomas Lowinsky', with a short introductory essay by his friend, the writer and critic Raymond Mortimer (who, like Lowinsky, was part of the Sitwell circle). The images are both gently satirical and wittily inventive. ('Daphne' here is a very different creature to cat.no.7!) Unusually, some handwritten notes relating to this project survive, in which Lowinsky states: 'All women shall be dressed in the latest fashions:– dresses, jewels, shoes, gloves, everything:– The backgrounds shall have the newest kind of buildings, both French and German, and American. There shall be seaplanes, motor cars (the most expensive kinds) also in the background – The most fashionable dogs – In short a record of the most up-to-date – cosmopolitan – rich and naughty woman'. He continues with 'ideas for a few full-page drawings': (A) perhaps a lady in a smart bathing dress talking to a sea god (B) a woman gardening, her hat being jauntily placed upon the stone head of a sinister male termmal [sic] figure (C) woman or women standing amidst broken columns, ruins, capitals of pillars upon the ground (in fact a kind of forum) while skyscrapers etc. tower against the sky in the background (D) woman or women in a hat shop. Very many hats being on the heads of amusing dummies (E) an elderly woman looking at a statue of skeleton cupid (skeleton wings and bones). This, I would suggest, as the last drawing in the book. (F) woman golfing upon the top of a cliff, the sea, a pier, and a man-o'-war being seen below … There could be river scenes, snow scenes

etc.'. Although not all these ideas found a place in the final product, these notes give us a rare and illuminating insight into Lowinsky's mental and visual processes. The cover of this book was designed by Lowinsky himself.

56 Sheridan, Richard Brinsley. *School for Scandal* (edited with an introduction by R. Crompton Rhodes)
Stratford-upon-Avon: Shakespeare Head Press; Oxford: Basil Blackwell, 1930. $11\frac{1}{2} \times 7\frac{7}{8}''$ (29.3 × 20); 154 pages; 475 copies (450 for sale, price £3 3s) +7 on Roman vellum
Katherine Thirkell née Lowinsky

This book receives a special mention in Frank Weitenkampf's *The Illustrated Book* of 1928, p.236: 'Thomas Lowinsky decorated Sheridan's *School for Scandal* … with a result that has an eighteenth-century feeling only in the externals of costume. There is an evident intention to have the illustrations go with the type, and the pale ink in which the pictures are printed makes them sink unobtrusively into the page'. Images evocative of stage sets preface each scene, and are interspersed with full-length depictions of the main characters in the play, most notable for their highly, almost perversely elaborate hairpieces. A copy of the book, which reproduces one of Lowinsky's own designs on its cover, was exhibited in the artist's 1949 memorial exhibition.

57 Lowinsky, Ruth. *Lovely Food, A Cookery Notebook*

London: The Nonesuch Press, 1931. $8\frac{1}{2} \times 5\frac{3}{8}$ (21.7 × 13.7); 127
pages; unlimited edition, price 6s; special edition of 500
copies on Batchelor Kelmscott handmade paper, price £1 1s
Justin Lowinsky

This was advertised in the 1931 Nonesuch Press *Prospectus* as 'a gay
book on the art and practice of cooking. It is not for old
gourmands to read in their dyspepsia; it does not claim to add
to the 'literature' of food; it is not history nor diatetics. It is a
practical manual of delicious, unusual, but always attainable
gastronomic delights. The illustrations of table decorations by
Mr Lowinsky show how far we have gone since the days of a
fern in a pierced silver pot, or a few heads of flowers afloat in a
flat black bowl. These pictorial suggestions are so various that
some will look well in the most Corbusier of dining-rooms,
others in the most Tudor of country houses'. The best of them
do indeed possess a wit that borders on the surreal, while Ruth
Lowinsky's written commentary is refreshingly sardonic.
Francis Meynell's autobiography, *My Lives* (p.200) contains an
amusing anecdote relating to this book: 'It occurred to me that
the talents of Ruth and Tommy might well be combined in a
Nonesuch cookery book, and they cheerfully agreed ... When
the drawings had been made and the recipes proofed for *Lovely
Food*, the Lowinskys came to dine with us, Ruth bringing with
her the manuscript of her introduction. I said that I would read
the introduction when we had dined. During dinner Ruth
showed a mounting uneasiness and afterwards begged for the
return of the introduction, in which, she said, she wanted to
make some changes, I persisted in reading it aloud. It included a
passage on how to choose your cook from among the
applicants for the post. "Never correspond with a cook – see
her and then ask her for her idea of a good menu for a dinner
party. If she suggests as an inspiration that it should start with

grapefruit and go on to *Consommé à la Royal*, a nice sole and a bird,
you can stop her before she proceeds to the inevitable
meringues and sardines on toast. Give her up as hopeless". A
mounting uneasiness? That, except for the sardines on toast,
was the identical dinner, course by course, that we had
provided.' Lowinsky's illustration to Menu 5 contains a
'primitive' African statuette, a reminder of his interest in this
type of art. (He was to give three such figures, bought by him in
the 1930s, to Rebecca West, a close friend of Ruth. These were
later sold at Christie's on 28 Nov. 1983.)

58 Laver, James. *Ladies' Mistakes*

London: The Nonesuch Press, 1933. $8 \times 5\frac{1}{4}$ (20.3 × 13.4); 106
pages; unlimited edition, price 6s; special edition of 300
copies on handmade paper, price 17s 6d
Justin Lowinsky

This volume included two poems by Laver, *A Stitch in Time* and
Love's Progress, already published separately by the Nonesuch
Press, plus a new poem, *Cupid's Changeling, or the Lady's Mistake*. All
three took the form of pastiches of eighteenth century moral
verse, and Alexander Pope in particular, and concern the
various amatory escapades and mishaps of three young ladies,
Belinda, Araminta and Miss Consuelo Mann. In John Dreyfus's
words (*A History of the Nonesuch Press*, p.150), 'Lowinsky appears to
have had found no difficulty in matching the period formality
of James Laver's couplets' – nor, one should add, their tongue-
in-cheek quality. The book was reviewed in *The Times Literary
Supplement* (23 November 1933), without, however, any mention
of the illustrations.

59 Lowinsky, Ruth. *More Lovely Food*
London: The Nonesuch Press, 1935. $8\frac{1}{2} \times 5\frac{3}{8}$ (21.7 × 13.7); 169
pages; unlimited edition, price 6s; special edition of 100
copies on handmade paper, price 15s
Justin Lowinsky

As the title suggests, this was essentially a sequel to *Lovely Food* of
1931. Like the latter, it contained the combination of ingenious
recipes and witty commentary by Ruth, and highly original, if
somewhat bizarre table decorations 'invented' by Tommy that
had made the previous publication such a success. This book
was still in print in June 1940.

Other Books illustrated by Lowinsky, but not exhibited

Drayton, Michael. *The Ballad of Agincourt* **and** *The Ode
to the Virginian Voyage.* Stratford-upon-Avon: Shakespeare
Head Press; Oxford: Basil Blackwell, 1926. These two poems,
originally published in *c.*1605, are among Drayton's (1563–1631)
best-known works.

Plutarch. *Lives of the Noble Grecians and Romans . . . ,*
translated by Sir T. North, 8 vols. Stratford-upon-Avon:
Shakespeare Head Press; Oxford: Basil Blackwell, 1928. 500
copies. Lowinsky designed the headpiece to the 'Dedication',
and a limited number of decorative medallions, which were
used to enclose portraits, based on contemporary likenesses,
of the famous men discussed in the text.

Wells, Herbert George. *Phoenix, A Summary of the
Inescapable Conditions of World Reorganization.*
London: Secker and Warburg, 1942. The cover image, also
used, in reduced form, for the title page, was Lowinsky's sole
contribution to this volume.

Lowinsky, Ruth. *What's Cooking, Recipes for the Keen
and Thrifty.* London: Secker and Warburg and Lindsay
Drummond, 1945. This book's appearance during a period of
food rationing and of material shortages in the publishing
world made it a much more modest affair than the two earlier
cookery books. Ruth Lowinsky was to continue her cookery
writing after her husband's death, with *Food for Pleasure* (1950)
and *Russian Food for Pleasure* (1953).

Pattern papers etc.

fig.13 'Shakespeare head motif' for the Shakespeare Head Press, 1920s

In addition to his book illustrations proper, Lowinsky produced a number of designs for minor items associated with the book trade, such as patterns for book covers and publisher's 'fleurons' or vignettes. In the 1920s, for example, he designed a Shakespeare head motif for the Press of that name (fig.13); in 1926, a publisher's imprint for Messrs G.P. Putnam's Sons; and in 1942, a motif for the dust jacket for H.G. Wells' *Phoenix* published by Secker & Warburg. As for his 'pattern papers' (an area in which, once again, Ricketts had been active at the Vale Press – although in general there was little precedent in this country for artist-designed papers, in contrast to Germany and Italy), he produced several of these for different publishers: for the Shakespeare Head Press (1926 and 1930, the latter being used for the cover of *School for Scandal*, illustrated by Lowinsky himself); for Longmans, Green & Co. Ltd (1931, for the book *King Queen Jack*), and for the Curwen Press, founded by Oliver Simon, nephew of William Rothenstein and Albert Rutherston, and founder too of The Fleuron and the Double Crown Club (see cat.no.45). Lowinsky also designed a vignette for Curwen, depicting a horn of plenty.

The two designs he created in 1928 for the Curwen Press, although put into production only after the Second World War, were reproduced in a 1928 publication (reissued, with extra text, in 1987) entitled *A Specimen Book of Pattern Papers designed for and in use at the Curwen Press*, for which Paul Nash wrote an introductory essay. In this he wrote the following: 'It is always unprofitable to compare a machine-made article with one made by hand. Pattern papers today are for the most part printed by machines with inks ... I should like to point out that ... the designs are not in imitation of the early Italian manner. On the other hand, they have their own virtue. These hard, bright, resilient patterns are more in keeping with the modern spirit and admirably represent the revival in pattern paper production'; and he concluded: 'This notable output by an English printer is another sign of the steadily growing conviction that distinction of design is not only aesthetically, but commercially important ... It is a lesson we are learning very late, but if we can learn it intelligently, and not like parrots, we may yet recapture what has been so long lost with us, a pride in style'. The book also included designs (printed, like those designed by Lowinsky, from lineblocks made from the original drawings) by Lovat Fraser, Rutherston, Margaret James, E.O. Hoppé, Edward Bawden and Paul Nash, and wood engravings by Nash, Enid Marx, Eric Ravilious and Harry Carter.

60 Curwen pattern paper, sample 1 1928

Lineblock print

Elizabeth and Robert Simon

This was shown in red on a plain paper in the 1928 specimen book mentioned above. In that guise, it was used as the cover for the literary monthly *Life and Letters*. In a white-line version, it was also available in dull red, dark yellow and light green. In the 1987 reprint of the book, it was printed, reversed out, in blue; this is the version displayed here.

61 Curwen pattern paper, sample 2 1928

Lineblock print

Elizabeth and Robert Simon

This was originally printed in light green; and in that form, included in the 1928 specimen book. In the 1987 publication, as here, it was printed in brown. Lowinsky's original drawing, in indian ink worked out on a pencilled grid, is in the Cambridge University Library (Morison Room xxvii. 280).

Textile Designs

Lowinsky's interest in interior decoration has already been noted (see p.17). His foray into the field of textile design seems to have come about as the result of his friendship with Allan Walton (1891–1948). Walton, originally trained as an architect and a painter, had set up his own manufacturing business, Allan Walton Textiles in 1933 (the retail outlet of which was in London's Berners Street), and proceeded to win a significant reputation by commissioning artists to create designs exclusively for him which would then be screen-printed by hand to achieve a marketable (if relatively costly) product. Hand screen-printing was particularly appropriate for artist-designed textiles, since it was far faster than block-printing, it offered a simple means of producing solid coloured grounds and enabled the spontaneity of the original design to be preserved intact. Being a flexible technique, which neither dictates pattern height nor restricts colours, it afforded plenty of scope for relatively cheap design experiments.

Although Allan Walton was not the only manufacturer to employ artists in this capacity, his choice of artists was unusually adventurous. That this lent his firm extra prestige and won him extra publicity is borne out by an article of 1933 in the journal *Decoration*, in which more than half a review of the fabrics displayed at the 1933 British Industrial Art exhibition is devoted to his company: the author describes the involvement of designers 'with such well-known names as Paul Nash, Duncan Grant, Vanessa Bell, Frank Dobson, Bernard Adenay, H.J. Bull, Cedric Morris, T. Bradley, Noel Guildford, Keith Baynes and, of course, Allan Walton himself' and notes approvingly that 'there has been no effort to dictate to these artists the type of design which they should produce. Each has freely expressed his personality'.

It was not until the latter part of the decade that Lowinsky joined the ranks of those mentioned above. Between approximately 1936 and 1938 he produced three designs for Walton, on the theme of 'fish', 'flowers and butterflies' and 'leaves and fruits'. These initially took the form of ink drawings which were then transferred to the screenprint medium and printed in a number of different colour runs. (The avoidance of pure, bright colours and the use instead of relatively restrained terracotta, blue and creamy hues was typical of the period.) A number of these designs screenprinted onto paper in black ink also survive. Donald King (*British Textile Design in the Victoria & Albert Museum*, Gakken, Tokyo, 1980, vol.III, p.xxi) has described how Walton 'gave his public a choice of ... painterly patterns [produced by artists like Vanessa Bell and Duncan Grant] or the straightforward geometric designs by H.J. Bull and T. Bradley'. Lowinsky's productions fall midway between these two extremes. While remaining faithful to the kind of motifs taken from the natural world that have at all times formed the staple of textile design, he subjects these to a distinctly modernist analysis, reducing organic forms to their essentials without, however, losing a sense of their biomorphic origins. Not surprisingly

perhaps, they were produced at a period in his life when in his paintings he had already abandoned the strange world of his imagination, and was confining himself to the more prosaic and earthbound realm of portraiture.

62

63

62 Fish pattern
Hand screen-printed textile. Modern print after late 1930s original design
Justin Lowinsky

63 Flower and Butterflies
Hand screen-printed textile (linen) (beige design on terracotta background). Late 1930s
Xenia Field

64 Flower and Butterflies
Hand screen-printed textile (linen) (cream design on mid-blue background) 1936/7
Trustees of the Victoria and Albert Museum

See cat.no.63 for illustration.

65 Leaves and Fruit
Hand screen-printed textile (chintz) (cream design on terracotta background) 1938
REPR: Schoeser, M. *Fabrics and Wallpapers*, p.29
Trustees of the Victoria and Albert Museum

65

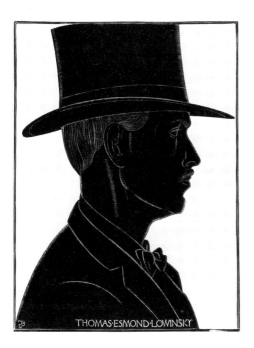

ERIC GILL

66 Thomas Esmond Lowinsky 1924
Wood engraving 11 × 8 (28 × 20.4)
Inscribed: (in reverse) 'EG' b.l.; 'Thomas Esmond
Lowinsky' (in capitals) b.c.
Justin Lowinsky

Gill (1882–1940), an acquaintance of Thomas Lowinsky, refers to this engraving, and to the two others, of Lowinsky's wife Ruth and sister Xenia Noelle, in a letter of 12 September 1924 addressed to the Rev. Desmond Chute: '. . . Also, I am doing three wood-engraved portraits, the Lowinsky family' (Shrewring, W. (ed.). *Letters of Eric Gill*. London: Jonathan Cape Ltd, 1947, p.182). All three images were subsequently illustrated in Gill, E. *Engravings of Eric Gill*. Bristol: Douglas Cleverdon, 1929. Although highly stylized, the print achieves a good likeness as well as being a striking and unusual image in its own right.

ALBERT RUTHERSTON

67 Family Tree 1925
Etching (edition of 60) 10 × 6½ (25.5 × 16.5)
Inscribed: 'AR 1925' b.r. (twice)
Justin Lowinsky

Rutherston (1881–1953) was a friend and professional associate of many years' standing: he and Lowinsky showed their work jointly at the Leicester Galleries in 1926 (where the Rutherston works included a Christmas card he had designed for the Lowinskys); both were active in the field of interior decoration and book illustration, and were members of the Double Crown Club (see cat.no.45). This charming 'family tree', celebrating the arrival of Lowinsky's third child and youngest daughter Clare in 1925, gives us an amusing insight into Lowinsky's lifestyle and interests. (Rutherston was later to become the godfather of the Lowinsky's youngest child, Justin.)

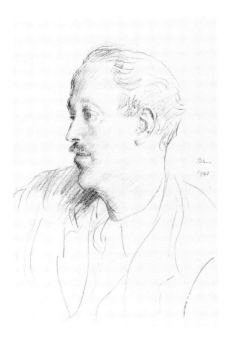

AUGUSTUS JOHN

68 Portrait of Thomas Lowinsky 1941

Pencil 19½ × 13½ (49.6 × 34.4)

Inscribed: 'John 1941' halfway up on right

Katherine Thirkell née Lowinsky

Augustus John (1878–1961) was a longstanding, close (if not intimate) friend of Lowinsky, whose talent the latter clearly rated highly, although, well aware of the compromises of which John was capable in later years, he was quite prepared to express his misgivings. In a letter to Brinsley Ford of 13 May 1941, for example, he refers to the portrait by John of Ford's wife Joanna which had been engineered by Lowinsky: 'I am delighted that we (with effort) brought Augustus up to scratch. But it has been really worth it. He is, to my mind, the greatest draughtsman alive today . . .'. (It was seeing the drawings of Brinsley and Joanna Ford which prompted Sacheverell Sitwell soon after to commission John to immortalize his own family.) Lowinsky must have admired not only the consummate fluency and bravura of John's drawing style (so diametrically opposed to his own), but – secretly perhaps – his colourful bohemianism and disregard of social convention as well – again, so very different to Lowinsky's own choice of lifestyle. This drawing was apparently the best (according to the sitter) of five John produced when Lowinsky was staying with him in early November 1941. John also produced pencil portrait drawings of Lowinsky's two sons.

Bibliography

ARTICLES AND EXHIBITION CATALOGUES

London, Ernest Brown and Phillips, The Leicester Galleries. *Paintings and Drawings by Thomas Lowinsky* (catalogue introduction by Osbert Sitwell), February 1926 (held simultaneously with *Paintings, Drawings and Designs by Albert Rutherston*). Reviewed *Artwork* 2 (1925/26), p.148

Chas. T. Jacobi. The Nonesuch Press. *Penrose's Annual, The Process Year Book and Review of the Graphic Arts*, vol.31, 1929, pp.17–20

Douglas Percy Bliss. Modern Book Illustration. *Penrose's Annual, The Process Year Book and Review of the Graphic Arts*, vol.31, 1929, pp.107–115

London, Wildenstein and Co. *Memorial Exhibition of the Work of Thomas Lowinsky (1892–1947)* (catalogue introduction by Sir Francis Meynell), 12 Jan.–12 Feb. 1949. Reviewed *Apollo*, Feb. 1949; *The Times*, 25 Jan. 1949; *The Daily Telegraph*.

Sheffield, Graves Art Gallery. *Thomas Lowinsky (1892–1947)*, 3 Jan.–1 Feb. 1981 (no catalogue, but reviewed in *Times Literary Supplement*, 16 Jan. 1981)

London, Barbican Art Gallery. *The Last Romantics, The Romantic Tradition in British Art, Burne-Jones to Stanley Spencer*, 1989

BOOKS

Cave, Roderick. *The Private Press*. New York; London: R.R. Bowker Company, 1983

Chamot, M., Farr, D. and Butlin, M. *The Modern British Paintings, Drawings and Sculpture*, vol.1. London: Tate Gallery; Oldbourne Press, 1964

Darton, F.J. Harvey. *Modern Book Illustration in Great Britain and America*. Special Winter No. of *The Studio*, 1931

Delaney, J.G.P. *Charles Ricketts, A Biography*. Oxford: Oxford University Press, 1990

Dolman, Bernard (ed.). *Who's Who in Art*. London: The Art Trade Press, 1934

Dreyfus, John. *A History of the Nonesuch Press*. London: The Nonesuch Press, 1981

Fifoot, Richard. *A Bibliography of Edith, Osbert and Sacheverell Sitwell*. London: Rupert Hart-Davis, 1971

Glendinning, Victoria. *Rebecca West, A Life*. London: Weidenfeld & Nicholson, 1987

Gwynne-Jones, Allan. *Portrait Painters, European Portraits to the end of the 19th Century and English 20th Century Portraits*. London: Phoenix House, 1950

Hone, Joseph. *The Life of Henry Tonks*, London; Toronto: William Heinemann Ltd, 1939

Houfe, Simon. *The Dictionary of British Book Illustrators and Caricaturists*, vol.2. Woodbridge, Suffolk: The Antique Collectors Club, 1978

Johnson, J. and Greutzner, A. *The Dictionary of British Artists 1880–1940*. Woodbridge, Suffolk: The Antique Collectors Club, 1976

Laughton, Bruce, *P.W. Steer*, Oxford: Clarendon Press, 1971

Lewis, Cecil Arthur (ed.). *Self-Portrait taken from the Letters and Journals of Charles Ricketts RA*. London: Peter Davies, 1939

Mallett, Daniel Trowbridge. *Mallett's Index of Artists, International-Biographical*. New York: R.R. Bowker Company, 1935/48/76

McColl, D.S. *Life, Work and Setting of P.W. Steer*. London: Faber & Faber Ltd, 1945

McKitterick, David. *A New Specimen Book of Curwen Pattern Papers*. Andoversford, Glos.: The Whittington Press, 1987

Meynell, Francis. *My Lives*, London; Sydney; Toronto: The Bodley Head, 1971

Moran, James. *The Double Crown Club: a history of fifty years*. London: Westerham Press, 1974

Nash, Paul (intro.). *A Specimen Book of Pattern Papers designed for and in use at the Curwen Press*. London: Curwen Press; The Fleuron Ltd, 1928

Newdigate, Bernard H. *The Art of the Book*. Special Autumn No. of the *The Studio*, 1938

Peppin, Brigid and Micklethwait, Lucy. *A Dictionary of British Illustrators, The Twentieth Century*. London: John Murray, 1983

Ransom, Will. *Private Presses and their Books*. New York: R.R. Bowker Company, 1929

Ridler, William. *British Modern Press Books, A Descriptive Checklist of Unrecorded Items*. London: Covent Garden Press Ltd, 1971 and 1975

Rothenstein, William. *Since Fifty, Men and Memories 1922–1938*. London: Faber & Faber, 1939

Schoeser, Mary. *Fabrics and Wallpapers (20th Century Design)*. London: Bell & Hyman, 1986

Simon, Herbert. *Songs and Words: A History of the Curwen Press*. London: George Allen & Unwin Ltd, 1973

Simon, Oliver. *Printer and Playground*. London: Faber & Faber Ltd, 1956

Symons, A.J.A., Flower, Desmond and Meynell, Francis. *The Nonesuch Century, An Appraisal, a Personal Note and a Bibliography of the first hundred books issued by the Press*. London: The Nonesuch Press, 1936

Thornton, Alfred. *Fifty Years of the N.E.A.C.* London: Curwen Press, 1935

Vollmer, Hans. *Allgemeines Lexikon der Bildenden Künstler des XX Jahrhunderts*, vol.3. Leipzig: E.A. Seeman Verlag, 1956

Water, Grant M. *Dictionary of British Artists Working 1900–1950*, vol.1. Eastbourne: Eastbourne Fine Arts, 1975

Weitenkampf, Frank. *The Illustrated Book*. Cambridge, Mass.: Harvard University Press, 1938

Who was Who, 1941–1950. London: Adam & Charles Black, 1980 (5th edition)

Lenders

Ashmolean Museum 28
Artist's granddaughters 35, 36, 37, 38
National Museum of Wales, Cardiff 3
Carlisle Museums and Art Gallery 22
Ferens Art Gallery, Hull 11
Xenia Field 24, 63
Justin Lowinsky 1, 4, 9, 15, 30–34, 39, 40, 42, 43, 45–51, 54, 55, 57–59, 62, 66, 67
Private Collections 5, 12, 21
Sheffield City Art Galleries 14, 20
Elizabeth and Robert Simon 60, 61
Clare Stanley-Clarke 6, 7, 8, 27, 41
Tate Gallery, London 10, 18, 25
Katherine Thirkell 26, 29, 52, 53, 56, 68
R. L. E. Thirkell, T. H. Nayani 2, 13
Serena Thirkell 17
T. G. L. Thirkell 16
Victoria and Albert Museum, London 44, 64, 65
Amcotts Wilson 23
Wolverhampton Art Gallery and Museums 19